C000176962

PAST & PRESENT

DOUGLAS COUNTY

OPPOSITE: In this c. 1889–1918 image, the Atchison, Topeka & Santa Fe Railway overpass crosses over the Denver & Rio Grande Railroad with a steam train carrying passengers. Near Sedalia, it was built in 1889 and discontinued during World War I. (Courtesy of Douglas County Libraries Archives and Local History.)

PAST & PRESENT

DOUGLAS COUNTY

Jean Jacobsen and Susan Rocco-McKeel

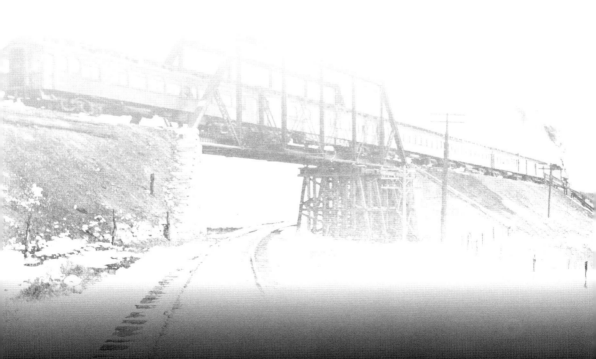

Dedicated to Michael Valentine McKeel, part of my history, for over 40 years of love, laughter, and unconditional support

—*Susan*

Dedicated to Jan (Jake) Jacobsen, my rock, love, and total support

—*Jean*

Copyright © 2023 by Jean Jacobsen and Susan Rocco-McKeel
ISBN 978-1-4671-0920-8

Library of Congress Control Number: 2022944589

Published by Arcadia Publishing
Charleston, South Carolina

Printed in the United States of America

For all general information, please contact Arcadia Publishing:
Telephone 843-853-2070
Fax 843-853-0044
E-mail sales@arcadiapublishing.com
For customer service and orders:
Toll-Free 1-888-313-2665

Visit us on the Internet at www.arcadiapublishing.com

ON THE FRONT COVER: Prior to 1940, Parker High School marching band members stand by the Ruth Memorial Chapel in Parker. The chapel was named for Dr. Heath's daughter, who died young. Serving as a Methodist Episcopal church until 1970, it is now a rental venue. (Past, courtesy of Douglas County Libraries Archives and Local History; present, photograph by Susan Rocco-McKeel.)

ON THE BACK COVER: In this early 1900s photograph, an unidentified woman sits on the Bandhauer cabin's porch. The flag has 48 stars. The Bandhauers ran cattle and built guest cabins for a resort. Robert held a patent for the meat hook still used in packing plants. The property became Shady Brook YMCA, near Deckers. (Courtesy of Douglas County Libraries Archives and Local History.)

CONTENTS

Acknowledgments vii

Introduction ix

1. Ranches and Farms 11

2. Business and Trade 27

3. Home and Hearth 51

4. Service and Assemblies 67

5. Land and Leisure 85

ACKNOWLEDGMENTS

Many people pointed us in directions we would not have otherwise seen, sharing their information and appreciation of local history. There are many to acknowledge, but especially for their time, expertise, and resources, many thanks go to Joan Gandy, Alyssa Carver, and Julia Waters, the archivists with Douglas County Archives and Local History; Brittany Cassell, curator, Douglas County Department of Community Development; Bill and Bev Noe, local historians and multigenerational Douglas County residents; and Barbara Belfield Machann, the Sedalia Museum and Gardens curator, historian, and "tour guide." We appreciate and thank Elizabeth Matthews, executive director for Schweiger Ranch; Cheryl Matthews, director of Open Space and Natural Resources for Douglas County; Mary O'Pry, Historic Douglas County, Inc.; Deby Williams, Sedalia Museum and Gardens; Ginger and Chuck Kissinger of Kime Ranch; Lynn Kay, Lorraine Ranch; Dan Dertz, planning resources manager, Douglas County Department of Community Development; John Oravez, Sedalia Fire Department; Terry Thompson, Sedalia Fire Department; Peg Wykes, owner and restorer of the I. J. Noe homestead; Diedre Mueller, Parker Water Department; Kelly Fausnacht, marketing manager, Parker Arts; Evelyn Small, Reuter-Hess descendant; Craig Banister and Norma Miller, volunteers for Douglas County Community Development Archives; Angie DeLeo, director, Castle Rock Museum; Claudine Phibbs, assistant, Castle Rock Museum; Larry Schlupp, Historic Douglas County, Inc.; and Michael V. McKeel, transportation, geolocation assistance, and tech support.

INTRODUCTION

Acquired through the Louisiana Purchase in 1803, Douglas County is one of the original 17 counties in the Colorado Territory. The first county seat was in Frankstown (now Franktown). In 1874, it moved to Castle Rock, still the county's largest municipality. According to Historic Douglas County, Inc., Douglas is "the most topographically and population diverse county in Colorado," encompassing a mix of rural acreages, cities, metro districts, plains, forests, mountains, bedroom communities, and villages.

Evidence of prehistoric rock shelters and campsites has been found in the Roxborough Archeological District dating back to at least the Early Archaic Period (5500–3000 BCE). The Lamb Spring Archeological Preserve contains bone beds of extinct Ice Age animals. The Franktown Cave is a rock shelter containing artifacts from 6400 BCE to AD 1725.

Hunter-gatherers populated the area before the Ute, Arapaho, and Cheyenne inhabited it. Most of the Arapaho, Cheyenne, Tabeguache, and White River Ute people were removed by the federal government to reservations after homesteaders, miners, and other settlers claimed the area.

Beginning with Russellville, the county's oldest settlement where gold was found in 1858, people continued to be drawn to Douglas County by the Homestead Act of 1862. Cattle ranches, agriculture, sawmills, and railroads contributed to the growth of Douglas County.

Castle Rock, Parker, and Larkspur developed by clustering around a railroad or stagecoach stop. Sedalia was a popular place for failed miners and Civil War veterans. The intersection of two creeks encouraged farming. Greenland depended upon trade, shipping clay, potatoes, lumber, milk, grain, and cattle. Louviers is unique in the county because it was created as a company town by DuPont for its dynamite factory. After DuPont pulled out in 1962, Louviers has remained a small, unincorporated village.

Some of Douglas County's early towns and settlements remain small, retaining their rural character, such as Sedalia, with a population of 171 according to the 2020 census. Others were established, such as the village of Castle Pines in 2008, which now has a population of 11,036. The unincorporated community of Highlands Ranch, founded in 1981, was once sparsely occupied open space and ranch land. It has a current population of 103,000.

Over 46 percent of the county's land is public or protected, encompassing two state parks, Roxborough and Castlewood Canyon, plus a portion of Pikes Peak National Forest. The county includes about 38 landmarked properties and five regional parks, defined as 50 acres or more supporting recreational activities. Local parks and quasi-private parks owned by HOAs multiply the options.

Douglas County Libraries became the third largest library system in Colorado in 2007. Many of the libraries had multiple locations; Castle Pines and Highlands Ranch expanded on their sites. Parker and Lone Tree built larger facilities on new sites in 2016–2017. The Castle Rock location, which houses the archives and local history department, is undergoing expansion.

The county includes at least three venues for entertainment and education: Parker Arts, Culture, and Events Center (PACE) in Parker, the Lone Tree Arts Center in Lone Tree, and the Douglas County

Events Center and Fairgrounds. It has two major shopping malls, the Outlets at Castle Rock and the Park Meadows Mall, as well as boutique and chain businesses.

In 1900, Douglas County's population was 3,210. By 1980, Douglas County had experienced a 140 percent growth. By 1995, it was named the fastest growing county in Colorado, and in 1997, it was named the fastest growing county in the United States. Covering 843 square miles between Denver and Colorado Springs, its current population is about 368,990, according to the 2020 census.

In 1940, about 67 percent of county land was covered by farms, decreasing to 38 percent in 1997. Retail is now the largest employer, followed by the government, but ranches, farms, and horse properties are still prevalent. Descendants of the original pioneers still populate the county. Some of the working ranches, original structures, and open spaces remain thanks to cultural and historical stewardship through private and public partnerships that include Douglas County Planning Department's Historic Properties, Douglas County Conservation District, Douglas Land Conservancy, Douglas County Open Space, local historic societies and nonprofits, and state historical organizations.

RANCHES AND FARMS

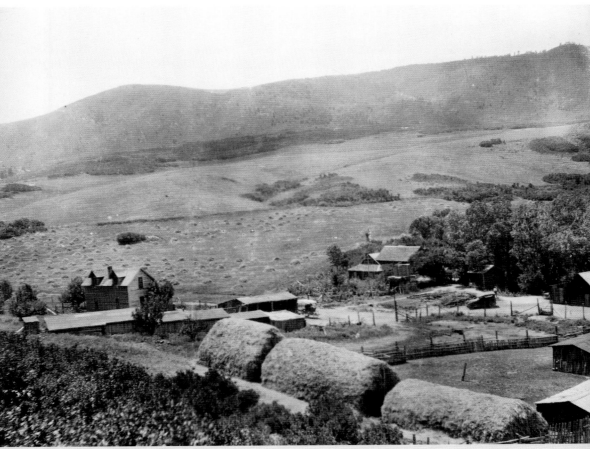

Shown between 1920 and 1940, the Penley family owned the Cam Glen or Penley Ranch until 2008. The ranch included timber, arable land, clay for building, and a small apple orchard amid pink and white rock formations. Near Sedalia, the ranch implemented small-scale farming, producing a variety of crops and dairy products. (Courtesy of Douglas County Libraries Archives and Local History.)

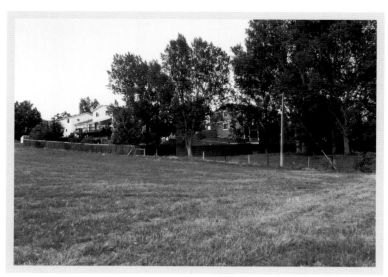

The Kime family has multigenerational ranching ties to the Parker area, with connections to the Rowley and Seibert ranching families. Said to be where the original "Marlboro Man" kept his horse, Kime Ranch used to stretch from east Parker across I-25 to the west. The barn, pictured in the 1920s, was located in what is now a residential neighborhood at the end of the pasture. (Past, courtesy of Douglas County Libraries Archives and Local History; present, photograph by Susan Rocco-McKeel.)

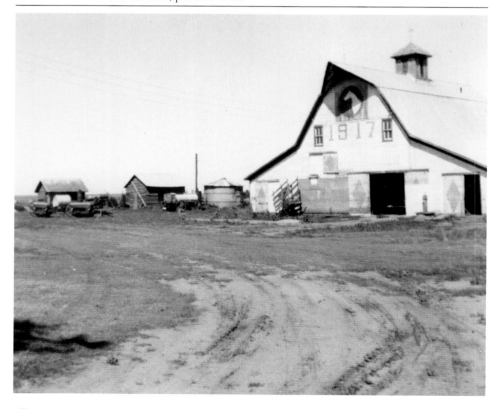

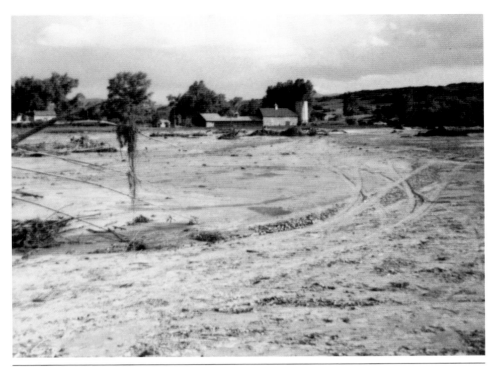

Sedalia's Duncan Ranch is still in the Duncan family. It is the site of several historic buildings, including a homestead cabin from the 1860s and a ranch house and barn from the 1880s. A conservation easement allows continuing alfalfa production while preserving 475 acres as open space. (Past, courtesy of Douglas County Libraries Archives and Local History; present, photograph by Susan Rocco-McKeel.)

A view from Charlford is shown during mid-1920s construction with an unidentified worker. The land combined the Blunt and Flower homesteads. When Mildred "Tweet" Kimball purchased it in 1954, she renamed it Cherokee Ranch. Kimball bred Santa Gertrudis cattle on the ranch. Protected by a conservation easement, 3,400 acres sponsor geological, archeological, and ecological programs. (Past, courtesy of Douglas County Libraries Archives and Local History; present, photograph by Susan Rocco-McKeel.)

RANCHES AND FARMS

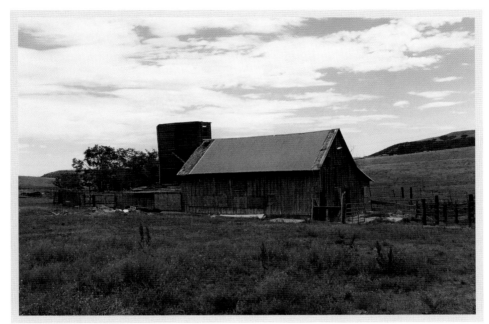

Joseph Lorraine purchased land in 1905 near Larkspur, forming a ranch that is now owned by his granddaughter. Hay would drop from the silo to feed the cows while they were being milked in the barn. This rare wooden, octagonal, and handmade silo, shown with unidentified women, is the only one of its kind remaining in the county. The silo's ranch is a Douglas County landmarked property. (Past, courtesy of Lynn Kay; present, photograph by Susan Rocco-McKeel.)

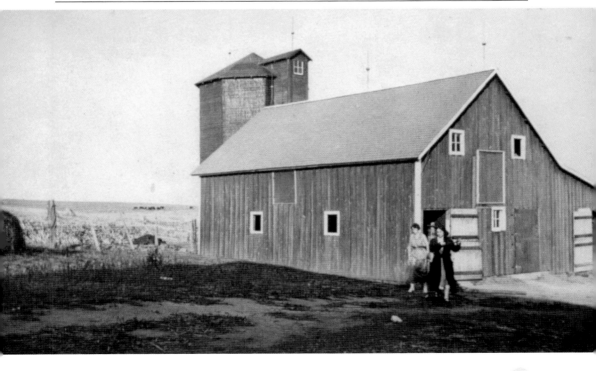

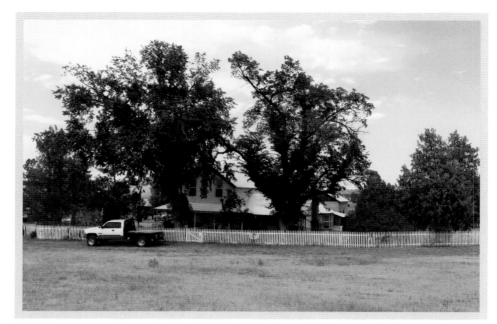

Oaklands Ranch is an official Colorado Centennial Ranch. The Curtis family has been living and working on this property for over 150 years. The original home, shown about 1880 with unidentified people, is still occupied. The farm operates a sawmill and sells Christmas trees. (Past, courtesy of Douglas County Libraries Archives and Local History; present, photograph by Susan Rocco-McKeel.)

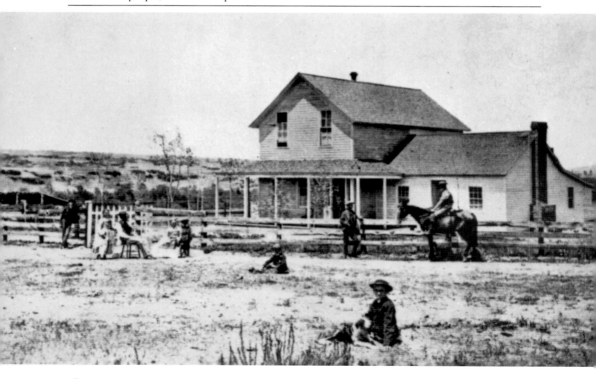

RANCHES AND FARMS

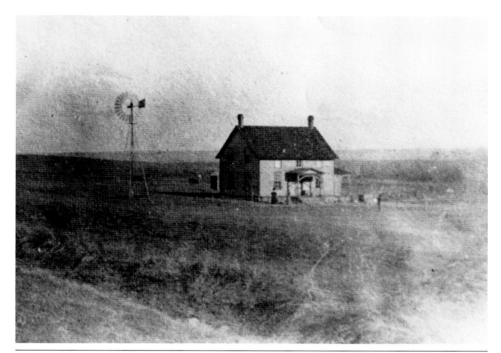

Tucked between a light rail station and other development in Lone Tree, Schweiger Ranch was founded by three Schweiger brothers in 1874. The original house, built around the 1870s or 1880s, has been renovated, as have the silo and barn. Now owned by a foundation, Schweiger Ranch is the recipient of an award for outstanding achievement in archaeology and historic preservation. The ranch now serves as a living history museum. (Past, courtesy of Douglas County Libraries Archives and Local History; present, photograph by Susan Rocco-McKeel.)

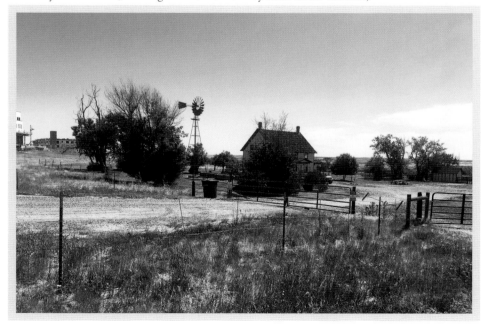

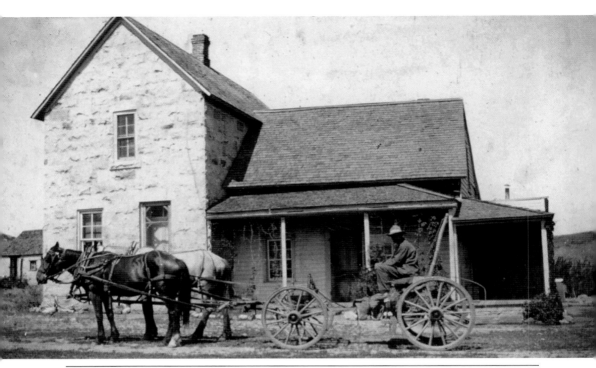

George Patrick Stewart owned Twin Creek Ranch, comprising 1,700 acres purchased under the Timber Culture Act, raising cattle. Stewart is driving the wagon with his rhyolite ranch house in the background. The former ranch is now a residential development, though multiple generations of his descendants still live in Douglas County. (Past, courtesy of Bill and Bev Noe; present, photograph by Susan Rocco-McKeel.)

South of Franktown, the Bihlmeyer Ranch with its multiple structures is shown in the early 1900s. Renamed Prairie Canyon Ranch, it continues to operate as a working cattle ranch. It is owned by the county to preserve historic values and protect wildlife. A historically restored blacksmith shop, smokehouse, residence, and barn are among the original structures still present. It is closed to the public. (Past, courtesy of Douglas County Libraries Archives and Local History; present, photograph by Susan Rocco-McKeel.)

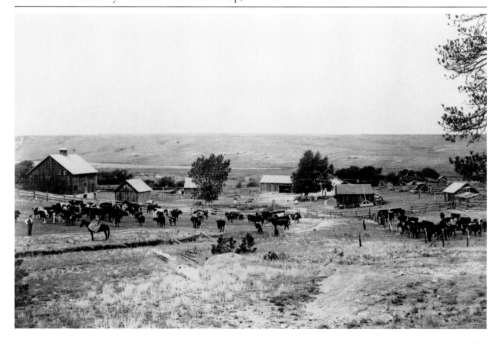

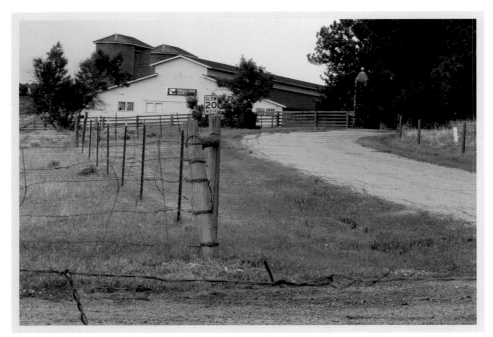

Part of the Diamond K Ranch, this wooden barn is shown in the 1930s. Now part of the Highlands Ranch Historic Park, it is leased as a working cattle ranch. Original Diamond K structures remain, including a mansion, ranch house, pastures, and windmill. (Past, courtesy of Douglas County Libraries Archives and Local History; present, photograph by Susan Rocco-McKeel.)

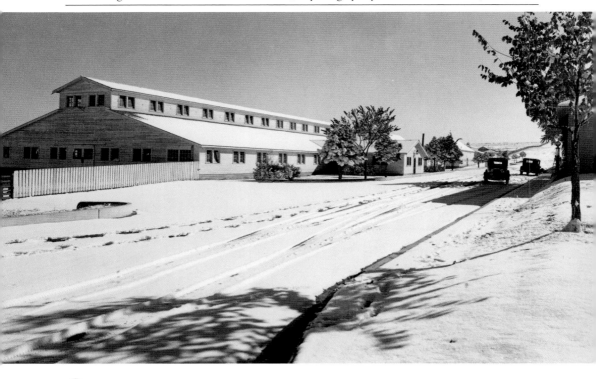

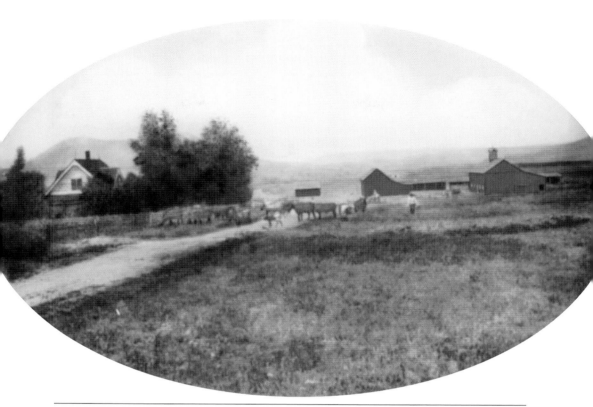

I.J. Noe, formerly the superintendent of the Greenland Ranch, established Eagle Ranch, perhaps named for the numerous eagles nesting in the nearby hills. Shown in the early 1900s, near Larkspur, the ranch raised cattle, with Noe's brand being the oldest in Colorado. The ranch produced potatoes, alfalfa, and grain. Family descendants still live in the area. Land ownership has been divided and changed hands. (Past, courtesy of Douglas County Libraries Archives and Local History; present, photograph by Susan Rocco-McKeel.)

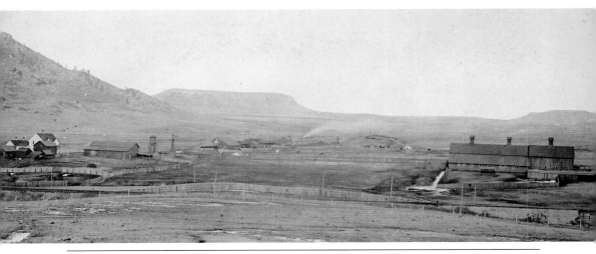

Originating in the 1870s as part of the Allis Ranch, Greenland Ranch sits west of Interstate 25. The longest continuously operating cattle ranch in Colorado, it comprised 15,000 acres, 1,600 head of cattle, and 500 horses. The red barn, rebuilt in 1922 after a lightning fire, accommodated 100 head of Thoroughbreds. Still a working ranch, conservation easements protect this landmarked property of about 11,000 acres. (Past, courtesy of Douglas County Libraries Archives and Local History; present, photograph by Susan Rocco-McKeel.)

In 1891, the San Carlos Ranch home stands behind Charles Hincke, driving a wagon. Hannah Aldrich feeds chickens to the right of him. Hincke was a professional photographer and raised cattle. The ranch is gone, but according to federal land patents, it would have been located east of Parker in the area of these fields, which are now large residential acreages. (Past, courtesy of Douglas County Libraries Archives and Local History; present, photograph by Susan Rocco-McKeel.)

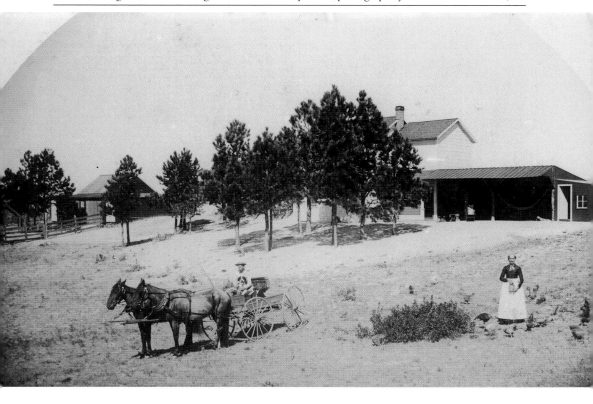

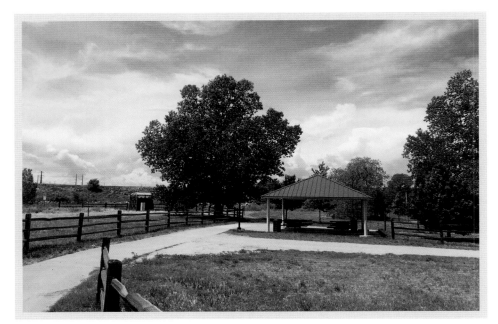

In 1994, this wooden barn stood as a remnant of a family farm in Parker, a reminder of the many that had dotted the area. The barn has been replaced by houses and the Bar CCC Park, with its ballfield and a trailhead. (Past, courtesy of Douglas County Libraries Archives and Local History; present, photograph by Susan Rocco-McKeel.)

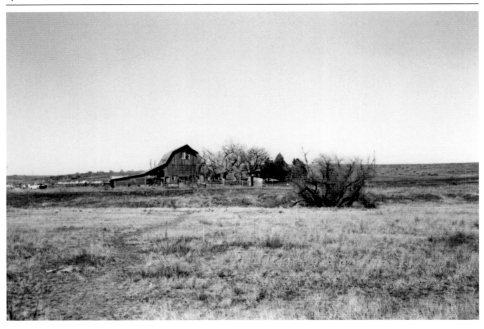

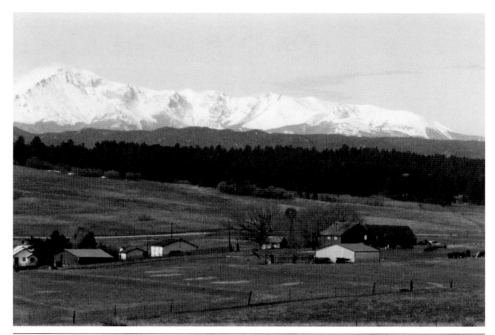

Composed of land homesteaded by the Lorraine and Buck families, Lorraine Ranch spanned over 800 acres. Owners Ada and Joseph Lorraine's daughter Ruth was a teacher who raised Polled Hereford cattle until her death in 1996. Shown in the early 1990s, the dairy farm had a cow and horse barn, machine shop, dairy shed, gas pump, and pond. Today, the structures, including the home, remain, but the pond is gone. (Past, courtesy of Lynn Kay; present, photograph by Susan Rocco-McKeel.)

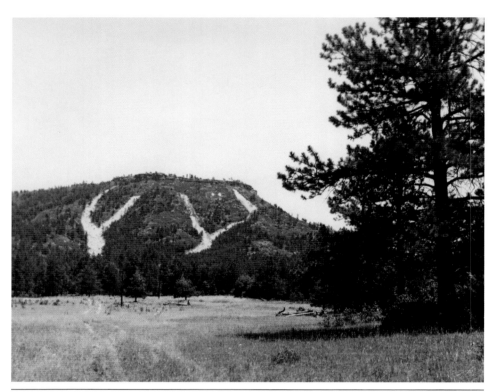

Dawson Butte, located on the Dawson Butte Ranch, stands southwest of Castle Rock. The land changed owners several times but continued as a ranching property. While portions of the former ranch still remain in private ownership, the Dawson Butte Open Space preserves a portion for scenic, wildlife, and recreation purposes with 7.7 miles of paths for horseback riding and hiking. (Past, courtesy of Douglas County Libraries Archives and Local History; present, photograph by Susan Rocco-McKeel.)

BUSINESS AND TRADE

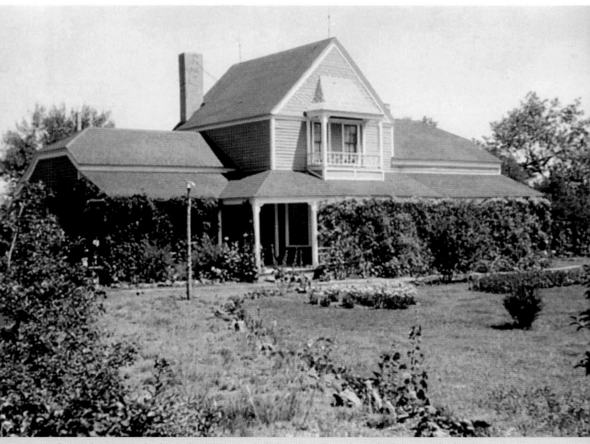

The Butler House, built in the 1870s, included the Cherry Croft Tea House. Riding the train from Denver, people would bring their bicycles to pedal the return on Perry Park Road. Some would stop there for refreshments. The house, with its additions, now stands in a heavily wooded area as a private residence. (Courtesy of Bill and Bev Noe.)

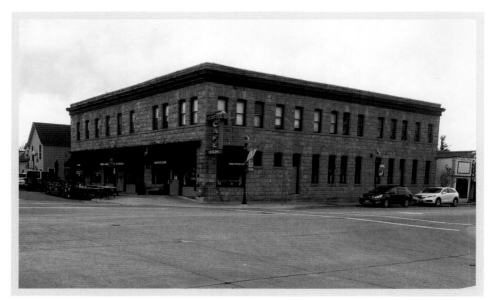

Pictured in the 1920s with an unidentified person, the Keystone Hotel, built from locally sourced rhyolite, still stands in downtown Castle Rock. A gathering place for quarry workers, it was reputed to be the "wildest" in the area. An extra deputy was hired for paydays. Today, it is a restaurant with second-level apartments. (Past, courtesy of Douglas County Libraries Archives and Local History; present, photograph by Susan Rocco-McKeel.)

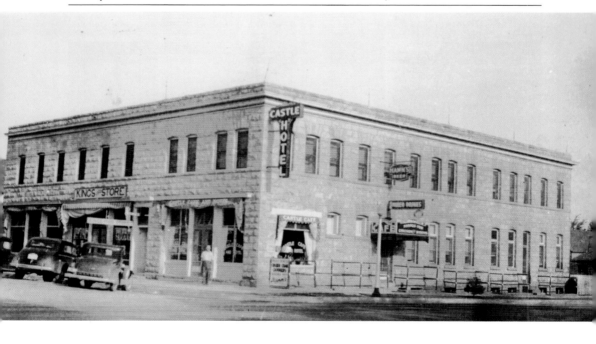

BUSINESS AND TRADE

Shown with unidentified people in the early 1900s, the Castle Rock Creamery helped farmers supplement their income. They would bring in their butterfat, and the creamery would make it into butter. A local newspaper of the time reported concerns that the butter markets were becoming unsettled "due to the influx of inferior cream." Now the site is a mortuary. (Past, courtesy of Douglas County Libraries Archives and Local History; present, photograph by Susan Rocco-McKeel.)

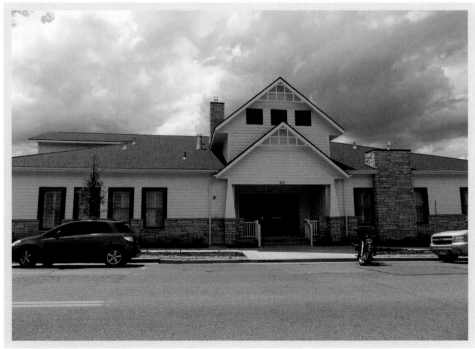

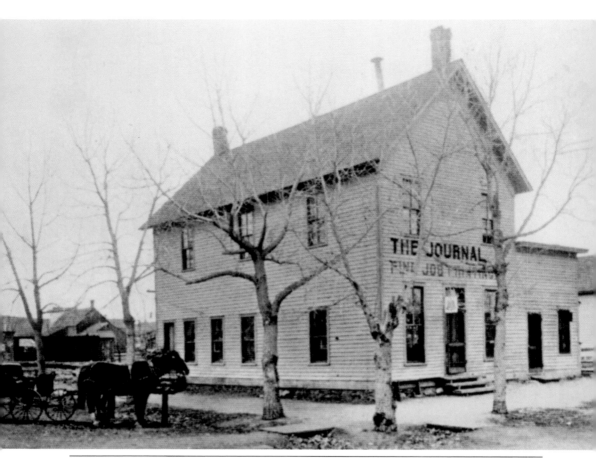

In 1900, this building was constructed to be a courthouse. Later, when a new courthouse was built, it was occupied by a community newspaper, the *Castle Rock Journal and Printing*. Much of the structure remains intact, housing another business. (Past, courtesy of Douglas County Libraries Archives and Local History; present, photograph by Susan Rocco-McKeel.)

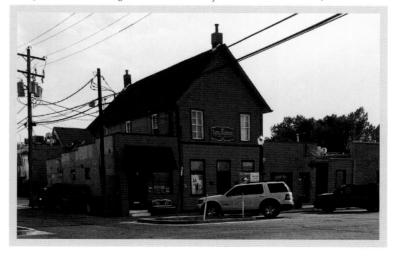

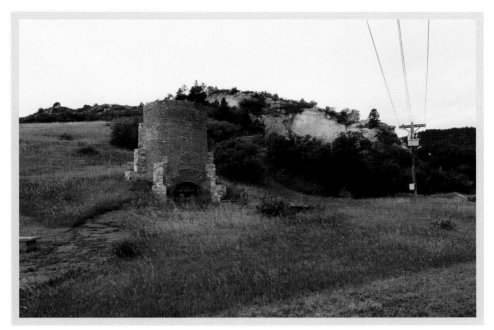

The Silicated Brick Company brickyard near Roxborough State Park opened in 1904 and was closed by 1919. The factory imprinted its white bricks with an "S." It played a major role in the development of industry and railroads in the area. Remnants of one kiln remain and are protected. (Past, courtesy of Douglas County Libraries Archives and Local History; present, photograph by Susan Rocco-McKeel.)

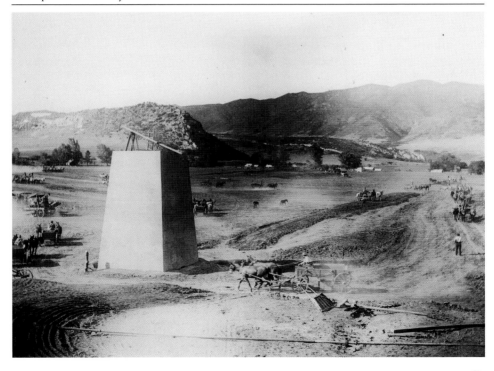

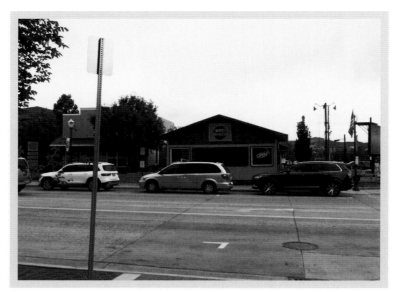

The Schweiger Motor Company building, pictured in 1931, was located on Wilcox Street in Castle Rock. This automobile garage and gas station was one of five in Castle Rock at the time. The station has been replaced by other commercial and residential development near the Riverwalk Park. (Past, courtesy of Douglas County Libraries Archives and Local History; present, photograph by Susan Rocco-McKeel.)

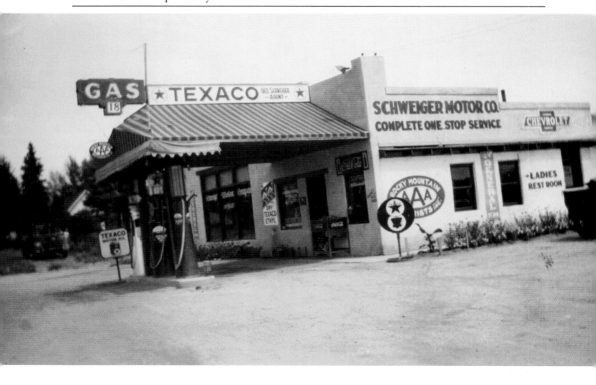

BUSINESS AND TRADE

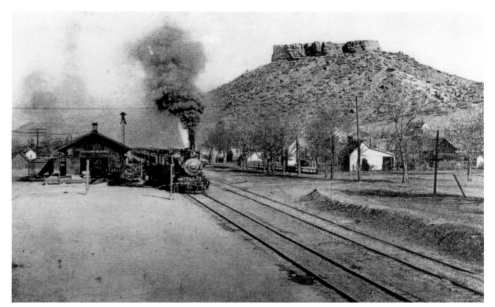

The Denver & Rio Grande Depot in Castle Rock is shown here between 1890 and 1910. The rhyolite depot was moved by semitruck in 1970 to its present location, where it serves as a museum with its baggage area, ticket counter, and graffiti wall. The former location is behind the Castle Rock Fire Department. (Past, courtesy of Douglas County Libraries Archives and Local History; present, photograph by Susan Rocco-McKeel.)

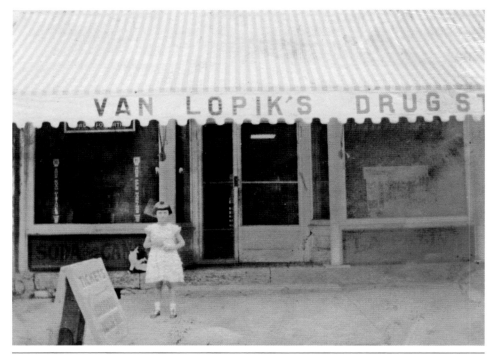

In 1926, Mary Van Lopik stands in front of her father's drugstore in Castle Rock. Justin Van Lopik operated the pharmacy from 1921 to 1952. Lopik became the president of the State Board of Pharmacy. A 1922 ad in the *Record Journal of Douglas County* reads, "Think of Van Lopik Drug Store as a Health Service Station." The building remains a commercial property. (Past, courtesy of Douglas County Libraries Archives and Local History; present, photograph by Susan Rocco-McKeel.)

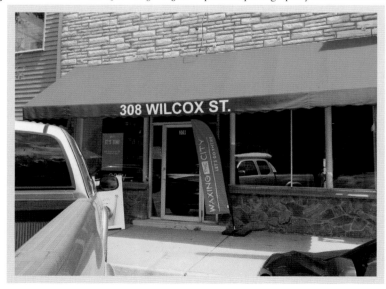

Two unidentified men stand in front of the Lewis Herzog store in Parker, on Mainstreet. One of the wagons holds a milk can. A sign on the building reads "McCormick Harvesting Machines," which would have been sold there. Situated on the site now are restaurants. (Past, courtesy of Douglas County Libraries Archives and Local History; present, photograph by Susan Rocco-McKeel.)

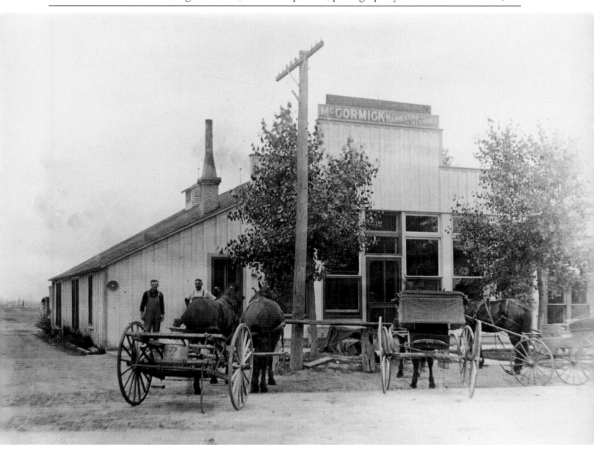

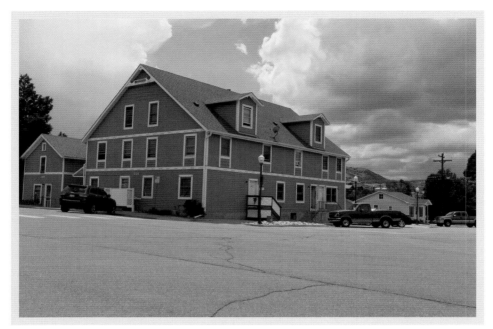

Holcomb and Whitney Hardware Dealers, shown below in 1900 in Castle Rock, sold general goods and lumber. Classes were held there when the first school burned down in 1896. It also served as a town hall for a time. Later, a furniture store, after it sustained fire damage, was rebuilt into apartments. (Past, courtesy of Douglas County Libraries Archives and Local History; present, photograph by Susan Rocco-McKeel.)

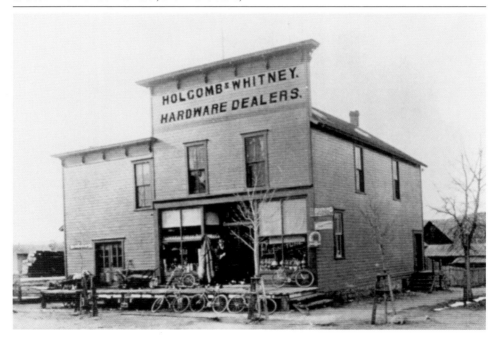

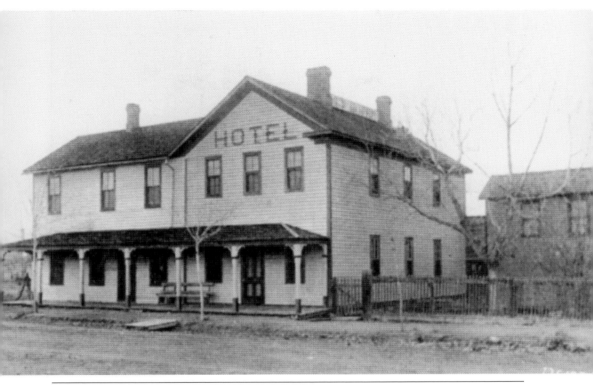

Shown above in 1900, City Hotel accommodated area travelers and railroad employees as the first building that marked Castle Rock as the county seat. The Harris brothers built it in 1874. The hotel moved from nearby New Memphis on log rollers to this site after Castle Rock became the growth hub. The building is a town historic landmark and a rental residence. (Past, courtesy of Douglas County Libraries Archives and Local History; present, photograph by Susan Rocco-McKeel.)

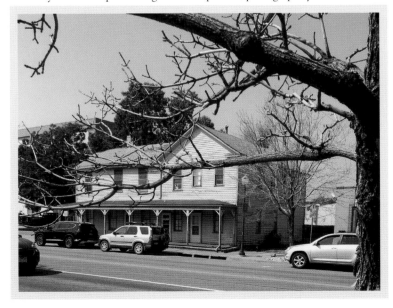

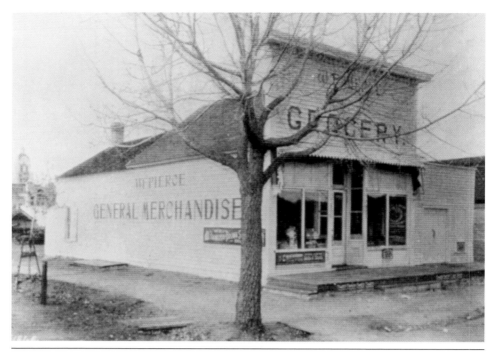

W.F. Pierce was a general merchandise store in Castle Rock. Walter Pierce opened the store in 1899, and it was closed as part of his bankruptcy proceedings in 1901. The site now includes modern buildings, restaurants, and businesses. (Past, courtesy of Douglas County Libraries Archives and Local History; present, photograph by Susan Rocco-McKeel.)

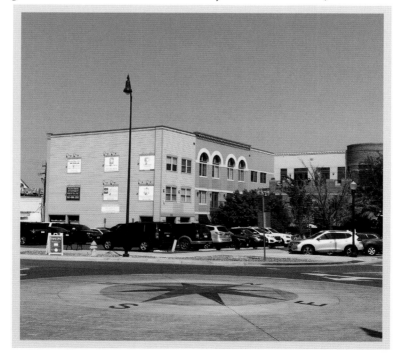

Taken around the 1930s, this shows the back of the lumber company, with an unidentified man carrying pails. The large rectangular building sat on the north side of Mainstreet in Parker; it closed in the mid-1930s and was torn down in the mid-1940s. O'Brien Park now stretches through the area near a swimming pool. (Past, courtesy of Douglas County Libraries Archives and Local History; present, photograph by Susan Rocco-McKeel.)

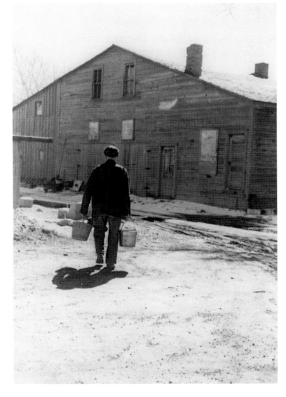

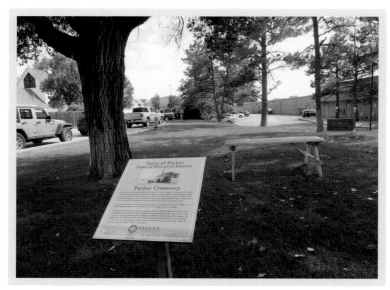

Opening in the early 1900s, the Parker Creamery is shown busy with wagons and unidentified people. It began as a milk station with separators and was owned by Otto Shatz. Local business people operated it. Later, a refrigeration unit was added to market and sell butter and ice cream. Some time in the 1920s, it was sold and then dismantled. The site sits behind current Parker businesses. (Past, courtesy of Douglas County Libraries Archives and Local History; present, photograph by Susan Rocco-McKeel.)

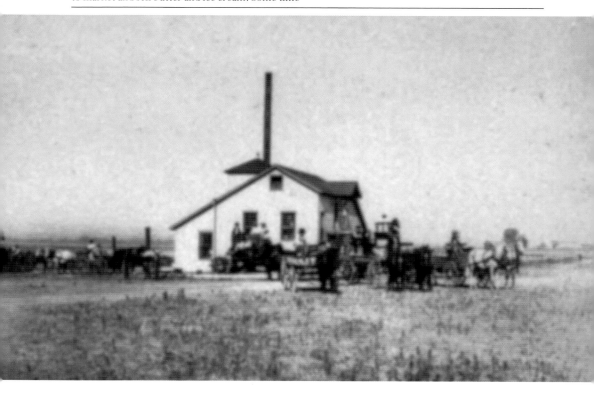

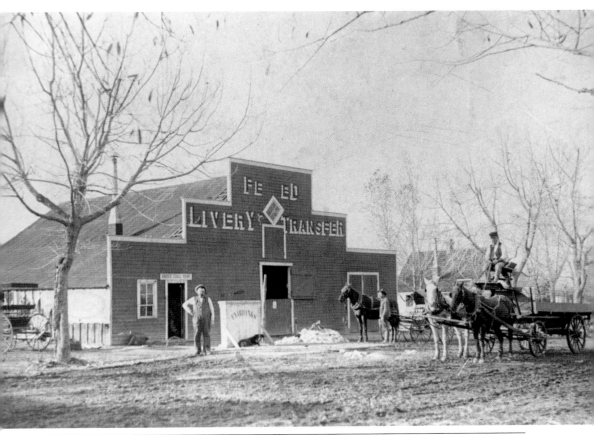

Seen here around 1916, the Sturdevant Livery provided "Feed Livery and Transfer" and also sold coal, according to its signs. The livery was located behind the Keystone Hotel in Castle Rock; travelers could stable their horses while eating or doing business. The former livery site is occupied by a parking lot and another business. (Past, courtesy of Douglas County Libraries Archives and Local History; present, photograph by Susan Rocco-McKeel.)

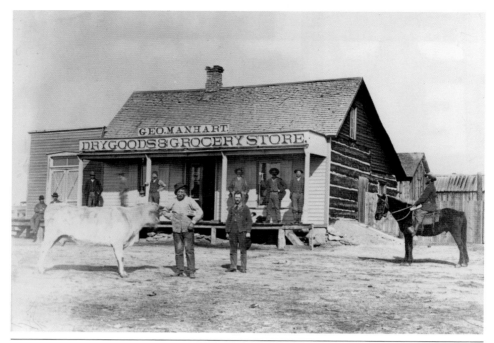

Sedalia's Manhart store operated for about 41 years. Marquis Victor holds a cigar box among other unidentified men. This shows the log structure in the late 1880s. Stone additions became part of a fine-dining restaurant that added a patio and facade, while the log structure would have been in its parking lot. (Past, courtesy of Douglas County Libraries Archives and Local History; present, photograph by Susan Rocco-McKeel.)

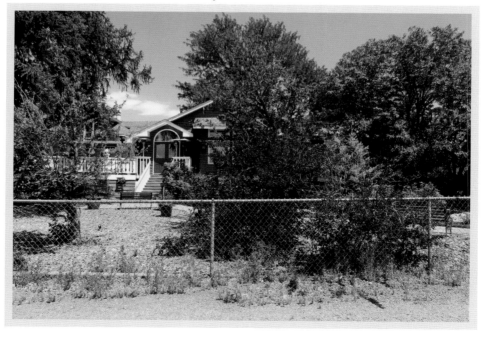

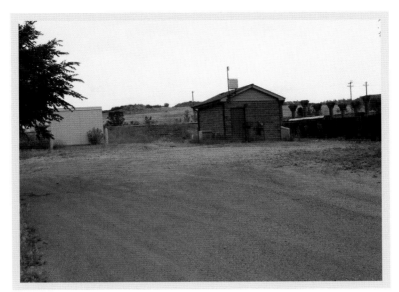

This is the Atchison, Topeka & Santa Fe Depot in Sedalia around 1880–1915. The community was originally named Round Corral and later Plum before becoming Sedalia. Railroads played a significant role in the development of the county, facilitating the transport of crops, cattle, and supplies. The depot no longer operates, but the small structure shown remains on private property. (Past, courtesy of Douglas County Libraries Archives and Local History; present, photograph by Susan Rocco-McKeel.)

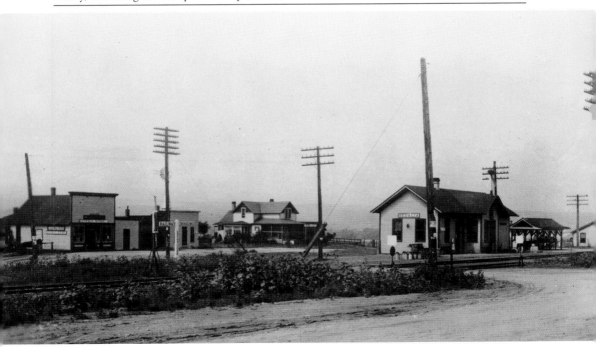

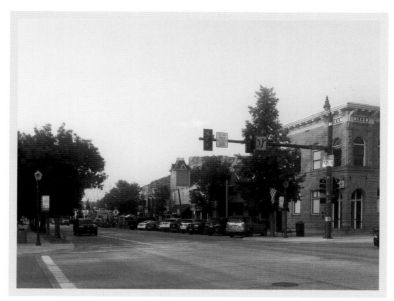

Shown about 1925, the First National Bank of Douglas County is constructed of local rhyolite. It represents the only known example of an architect-designed Romanesque Revival–style building in Castle Rock. The bank closed during the 1929 stock market crash and never reopened. Now used as a Masonic temple, the building has local and national historic designations. (Past, courtesy of Douglas County Libraries Archives and Local History; present, photograph by Susan Rocco-McKeel.)

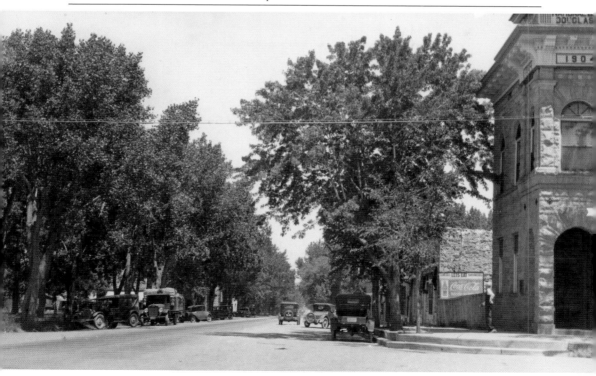

BUSINESS AND TRADE

In this mid-1920 image, businesses are shown eastward along Parker's Mainstreet, which cannot legally be spelled "Main Street" because it does not run north to south but east to west. Ruth Memorial Chapel, on the far left, still stands, but the other businesses have been replaced—some more than once. (Past, courtesy of Douglas County Libraries Archives and Local History; present, photograph by Susan Rocco-McKeel.)

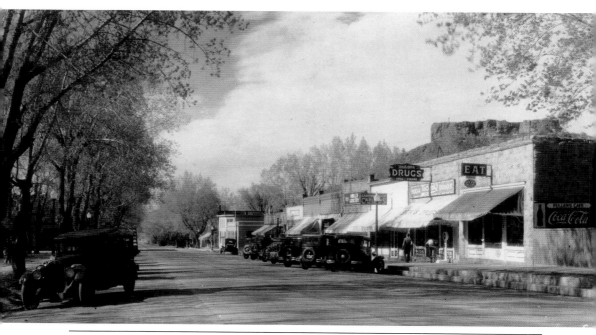

In 1931, Wilcox Street in Castle Rock featured a row of businesses, including Van Lopik Drug Store, Fuller's Café, Carlson's sandwich shop, and Kroll's Grocery. The view is looking north. Today the block looks much the same, but the businesses have changed. The building with an awning in the center that was Van Lopik Drug has an awning today. (Past, courtesy of Douglas County Libraries Archives and Local History; present, photograph by Susan Rocco-McKeel.)

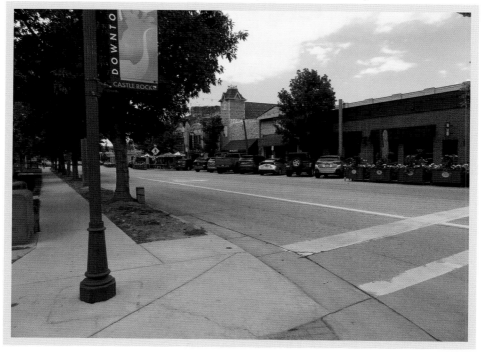

Once a stagecoach stop, Larkspur had the Denver & Rio Grande running through it. Shown in the 1920s, the center white building was the Frink Creamery. The east-west road is an old highway. The railroad tracks are visible today, still used but not as the major transportation mode as it was in the past. (Past, courtesy of Douglas County Libraries Archives and Local History; present, photograph by Susan Rocco-McKeel.)

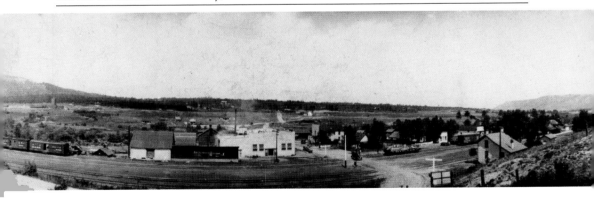

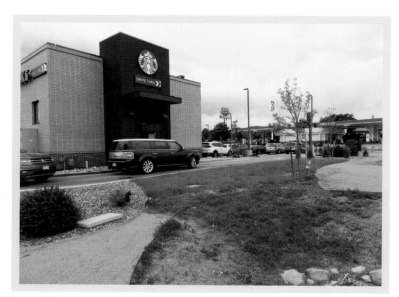

The Sinclair gas filling station was located on the Wolfensberger Road exit from Interstate 25 to Castle Rock in this 1999 view. A coffee shop has replaced the demolished station. The Wendy's in the background still exists, as does the filling station on the right, though owned by a different company. (Past, courtesy of Douglas County Libraries Archives and Local History; present, photograph by Susan Rocco-McKeel.)

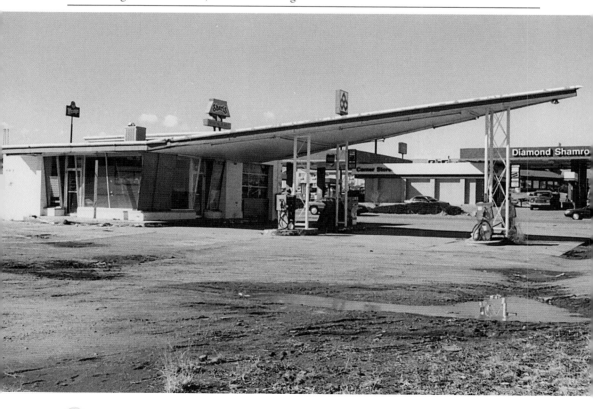

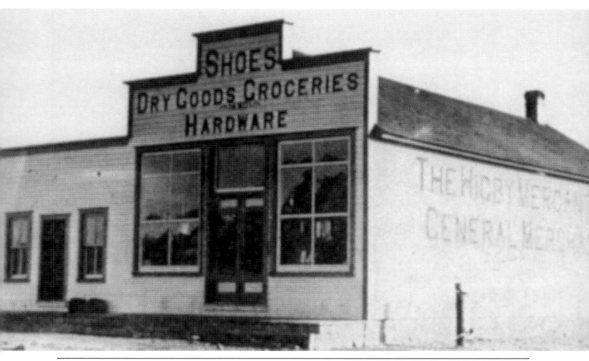

At the Greenland townsite, Higby's family store operated from 1907 to 1932, selling general merchandise, gas, farm equipment, produce, and Model Ts. The Higby family once owned the Greenland Ranch. During its peak, Greenland had a saloon, a hotel, two blacksmith shops, and a school, among other establishments. A new facade reminiscent of the store sits on the site that features covered picnic tables near a trailhead. (Past, courtesy of Douglas County Libraries Archives and Local History; present, photograph by Susan Rocco-McKeel.)

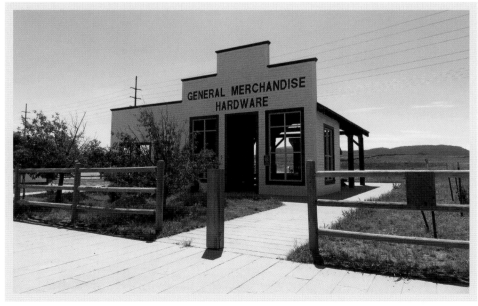

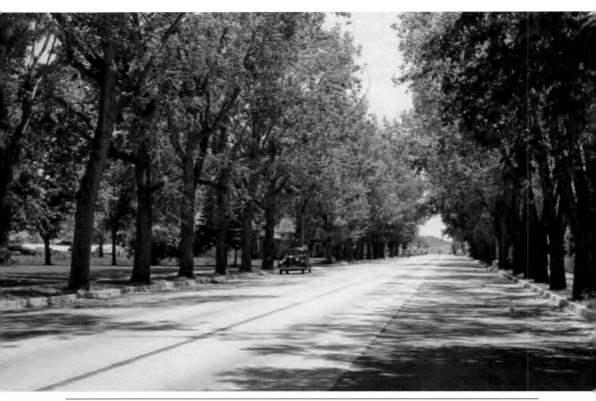

During the late 1920s, in Castle Rock, Wilcox Street, shown at the north end looking southward, was the main road connecting highways to Boulder and Greeley prior to the construction of Interstate 25 to the west of Castle Rock. Wilcox is still the main street in the town, but the large trees lining the street are gone. (Past, courtesy of Douglas County Libraries Archives and Local History; present, photograph by Susan Rocco-McKeel.)

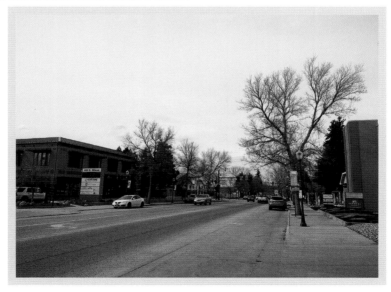

HOME AND HEARTH

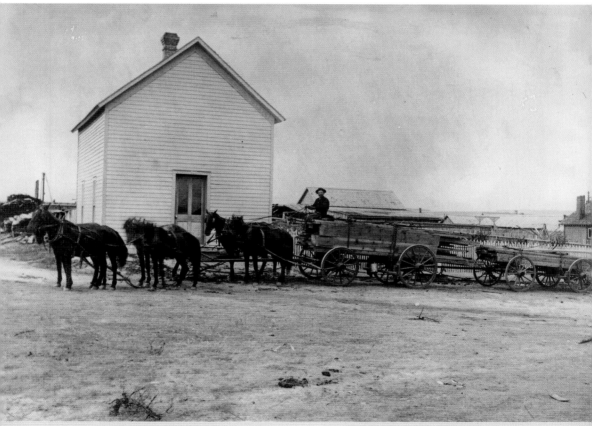

In this c. 1880–1920 image, Adolph Fulmer handles horse teams pulling wagons with logs and sawn lumber in front of Lewis Beeman's wooden home in Sedalia. In the 1930s, Harriet Beeman chaired the all-female Sedalia Fire Department board and was a volunteer firefighter. The department has a long history of female firefighters. (Courtesy of Douglas County Libraries Archives and Local History.)

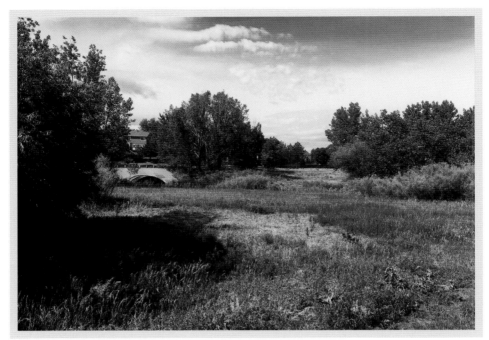

The c. 1800s image below shows the original log cabin on the Rowley/Kime ranch area in Parker, where Frank Kime was born. Located near a creek in Parker, the cabin was moved to higher ground on logs after being flooded. The original site is part of a neighborhood park that completed flood mitigation after the bike trail and some area yards were flooded. (Past, courtesy of Douglas County Libraries Archives and Local History; present, photograph by Susan Rocco-McKeel.)

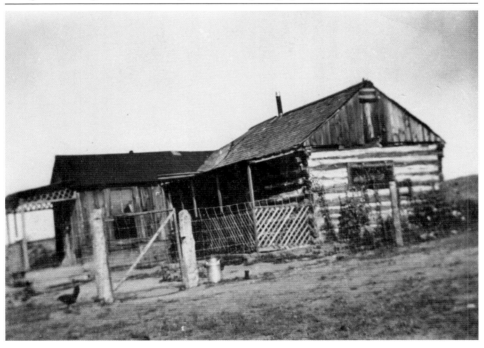

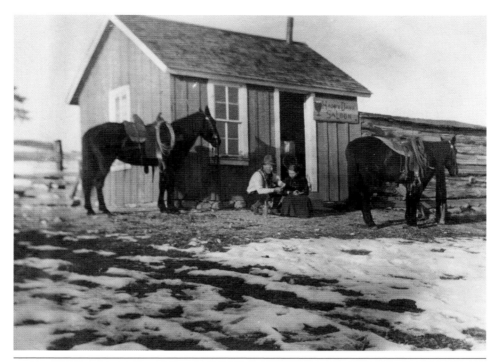

In the early-1900s image above, an unidentified couple sits while horses stand outside the bunkhouse on the Bihlmeyer ranch land originally belonging to the Seubert, Bihlmeyer, and Bartruff families. Renovated and staged today as a saloon on the renamed Prairie Canyon Ranch, it is an example of coordinated protection by public and private organizations. (Past, courtesy of Douglas County Libraries Archives and Local History; present, photograph by Susan Rocco-McKeel.)

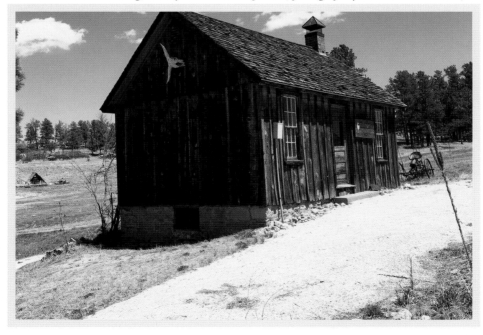

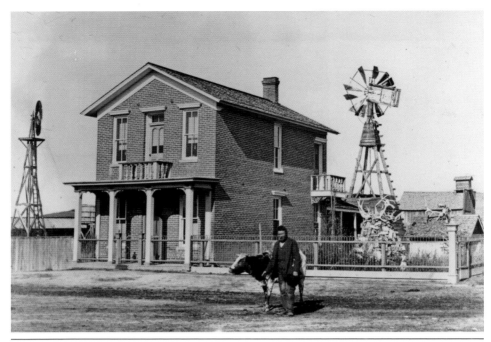

With its 10-hole outhouse, this was considered the finest house in Sedalia in the 1800s. The owner, Marquis Victor, is shown standing in front of his house. Victor was the village blacksmith and considered the closest thing to a doctor in the town, having served under a Civil War surgeon. The Victor house remains a residence with an addition on the back. (Past, courtesy of Douglas County Libraries Archives and Local History; present, photograph by Susan Rocco-McKeel.)

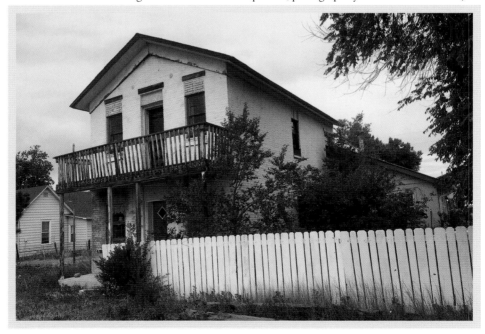

HOME AND HEARTH

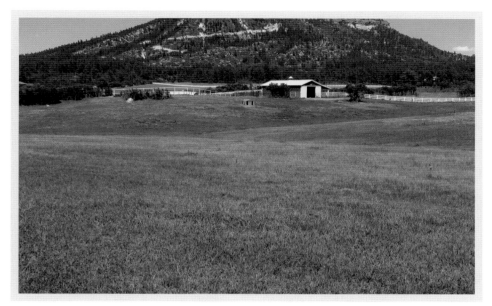

James McInroy built the MacHurst Ranch around 1897 near the base of Raspberry Butte. It is shown after the devastating 1965 flood; the Douglas County Highway Department used the mud flow debris as fill when rebuilding flood-damaged roads. In 2015, the farm changed to Crooked Willow, a horse property and event venue with additional structures. (Past, courtesy of Douglas County Libraries Archives and Local History; present, photograph by Susan Rocco-McKeel.)

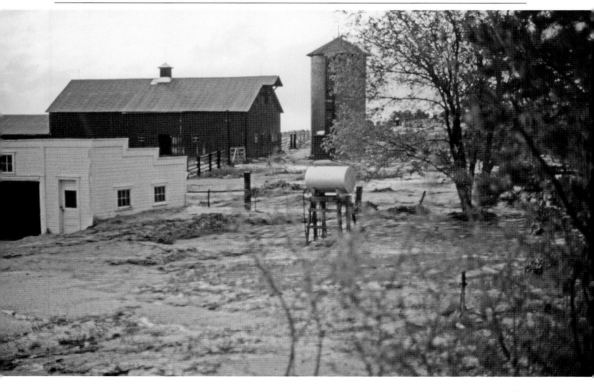

In the late 1800s–early 1900s image below, unidentified members of the I.J. Noe family gather in front of his homestead on Eagle Mountain Ranch. The family lived in the house for over 110 years. Due to inheritance taxes and economic factors, the land was divided and sold over time. The home's new owner has restored the house and other structures, keeping horses on the property. (Past, courtesy of Bill and Bev Noe; present, photograph by Susan Rocco-McKeel.)

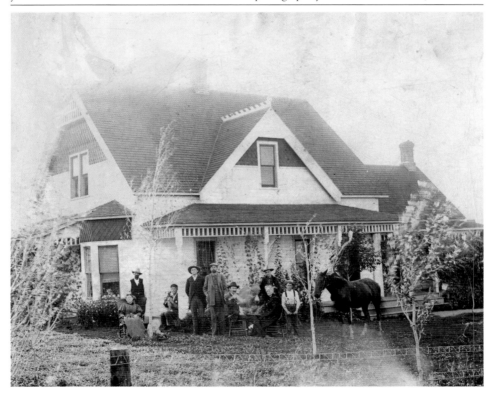

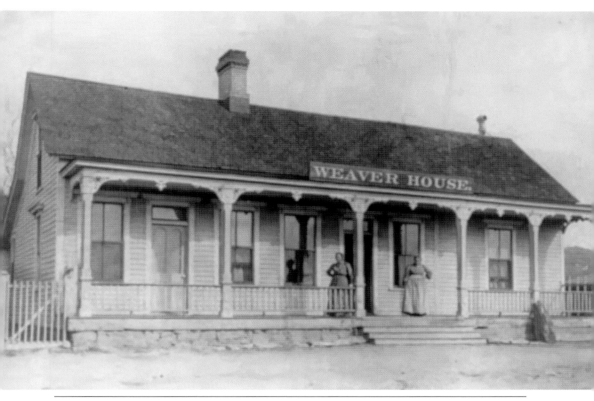

Two unidentified women stand in front of the Weaver House in Sedalia around 1898–1910. The residence was also a business, used as a hotel that supported the nearby corral and livery stable. The hotel was one of many women-run businesses in early Sedalia. An industrial business covers the space where the Weaver House once stood near what is now an alley. (Past, courtesy of Douglas County Libraries Archives and Local History; present, photograph by Susan Rocco-McKeel.)

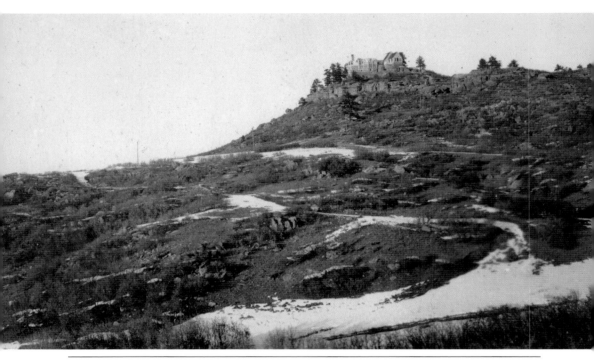

Charles Alfred Johnson commissioned the construction of Charlford, shown from a distance in 1924–1926. He designed it after a 1450s-style Scottish castle. Later, Mildred "Tweet" Kimball purchased it, renaming it Cherokee Castle. Kimball lived there from 1954 to 1999. The Cherokee Ranch & Castle Foundation owns the deed. The castle, located in Daniel's Park, is a venue for special events and educational programs. (Past, courtesy of Douglas County Libraries Archives and Local History; present, photograph by Susan Rocco-McKeel.)

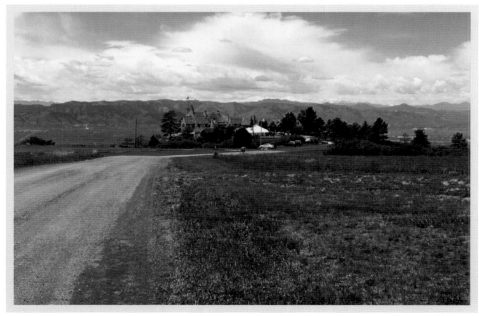

Plum Avenue in Sedalia, seen here some time between 1880 and 1920, was a major street in the small town. A water tower and windmill can be seen. Businesses located along Plum Avenue, with its easy access to the railroad. The railroad tracks have moved since that time, and the businesses have changed, but this original house remains in what is now a residential section of the street. (Past, courtesy of Douglas County Libraries Archives and Local History; present, photograph by Susan Rocco-McKeel.)

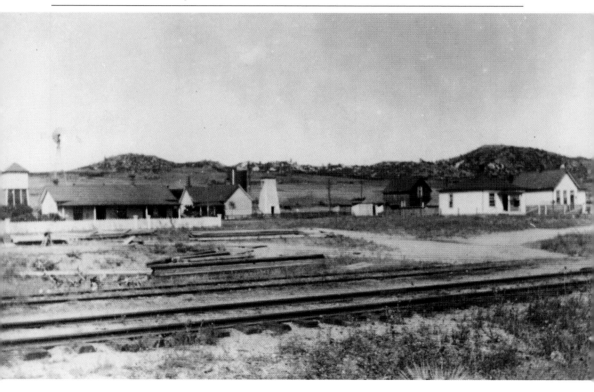

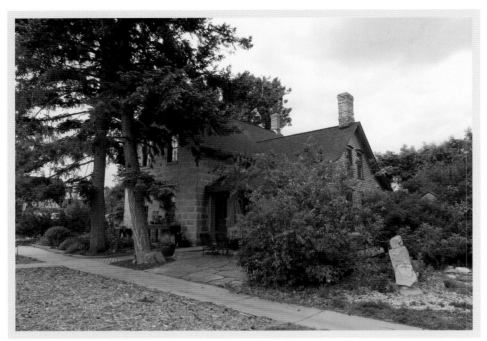

Benjamin Hammar built this house in 1881. Hammar's large sheep ranch irritated the local cattle ranchers, causing Hammar to move his ranch out of the county. In 1902, Dr. George Alexander purchased the Castle Rock home, locating his medical practice on the first floor. Alexander was recognized as one of the five longest-practicing physicians in the United States. Others live in the house today. (Past, courtesy of Douglas County Libraries Archives and Local History; present, photograph by Susan Rocco-McKeel.)

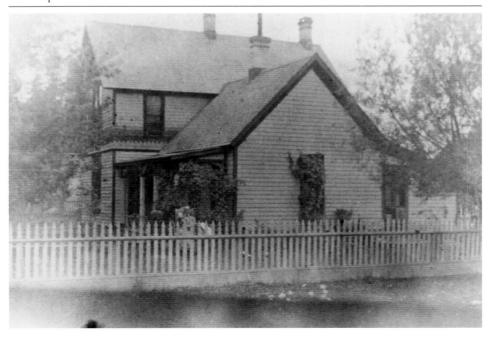

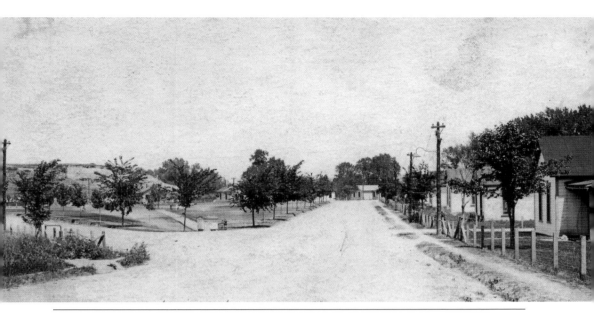

About 1906, DuPont established Louviers as a town for its dynamite plant. The Flats, shown in 1920, provided company housing to the workers. Location and size reflected the employee's status. Plant workers lived on the lower ground, while company executives lived on hills. After the plant closed, DuPont sold some houses to workers and removed others. Some original homes remain, seen in the distance. (Past, courtesy of Douglas County Libraries Archives and Local History; present, photograph by Susan Rocco-McKeel.)

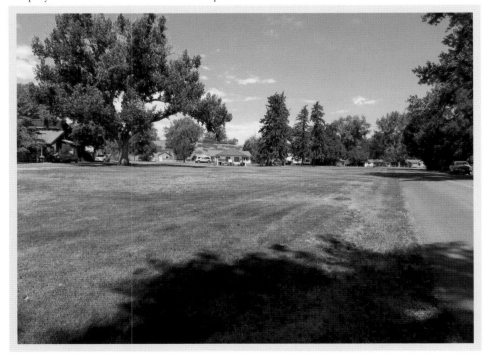

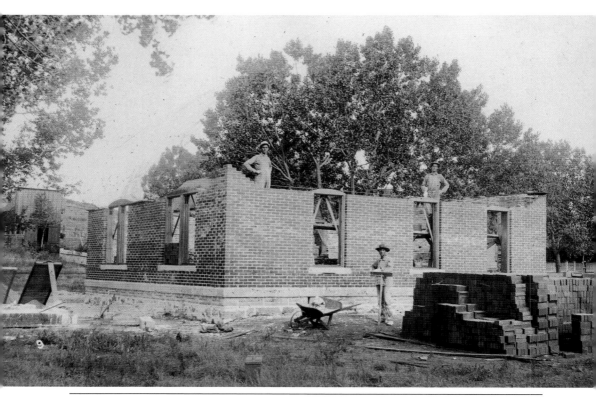

William Cantril was a member of a prominent family who contributed to Castle Rock's development. He built the first Douglas County Courthouse after moving to Castle Rock in the early 1900s. His family home, under construction about 1899, is a square brick building in the Craig & Gould Addition. Cantril House, with a south side addition, is now an assisted living facility for seniors. (Past, courtesy of Douglas County Libraries Archives and Local History; present, photograph by Susan Rocco-McKeel.)

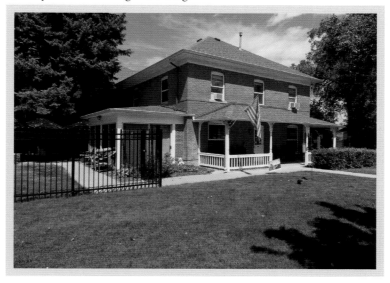

HOME AND HEARTH

The George Patrick Stewart family had a house on their homesteaded Twin Creek Ranch. Due to the long drive to Castle Rock, Amelia and the children moved to this house, built in 1902, for the school year. The family sold the actual rock of Castle Rock and 20 acres to the town for a token fee in 1947. The house is now owned by another family. (Past, courtesy of Bill and Bev Noe; present, photograph by Susan Rocco-McKeel.)

Shown in 1899, from left to right, Sarah, Clarence, Washington Irving, and Clara Whittier stand in front of their home in Castle Rock. Sarah and Washington homesteaded in the Rock Ridge area of Douglas County, where Washington was a postmaster at the Case Post Office until it closed. Sarah ran a dress shop from the home. The house may become part of a commercial complex. (Past, courtesy of Douglas County Libraries Archives and Local History; present, photograph by Susan Rocco-McKeel.)

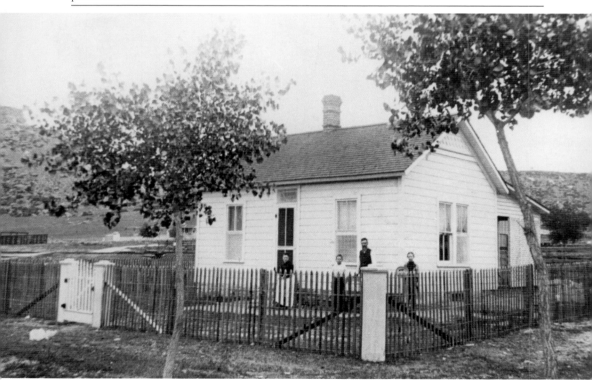

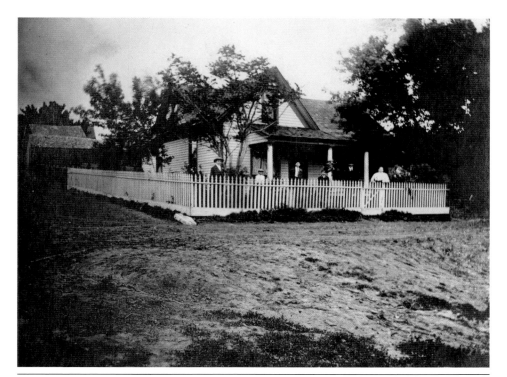

Some time between 1905 and 1925, unidentified members of the Jerry Noe family are pictured standing around their wooden house on their homestead in Larkspur. Located off Fox Farm Road, the home is gone. A new owner built a home on the ranch property in the 1960s. (Past, courtesy of Douglas County Libraries Archives and Local History; present, photograph by Susan Rocco-McKeel.)

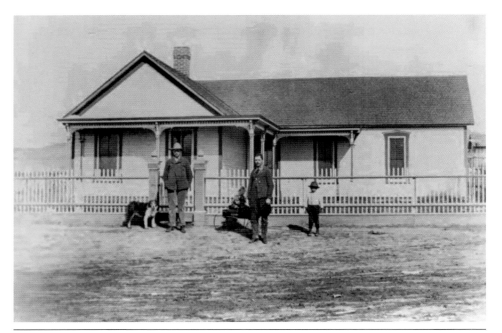

The Manhart family had a frame home next to their store around 1890–1920 in Sedalia. Unidentified people, many probably family members, stand in front of the picket fence. The stone store can be seen at the right end of the photograph. It is now part of a restaurant with a brick facade and additions. (Past, courtesy of Douglas County Libraries Archives and Local History; present, photograph by Susan Rocco-McKeel.)

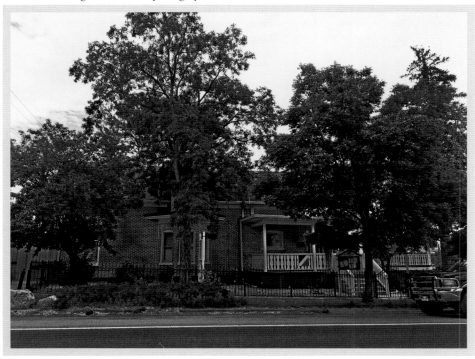

SERVICE
AND ASSEMBLIES

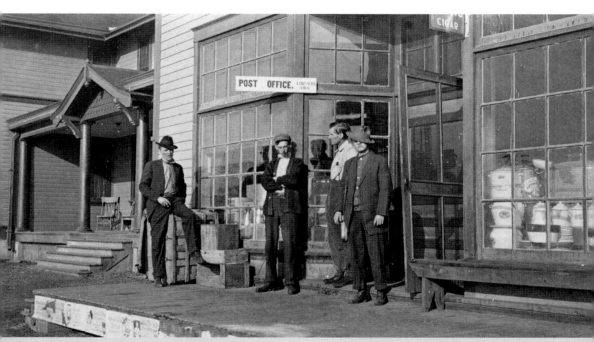

In 1920, Frank Clark stands with his two sons and an unidentified man outside the Louviers Hotel and Shop, with a sign reading "Post Office Louviers, Colo." Similar to many small settlements and villages in Douglas County, post offices were often combined with other businesses and sometimes established in homes. (Courtesy of Douglas County Libraries Archives and Local History.)

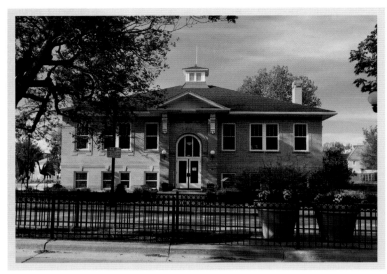

The Parker Consolidated School was built in 1914–1915. It served grades one through twelve until 1958, when high school students moved to a Castle Rock facility. In 1967, its use as a school was discontinued, though portions of the building housed other entities such as a preschool and the Parker Food Bank. The Town of Parker purchased it for cultural programming. (Past, courtesy of Douglas County Libraries Archives and Local History; present, photograph by Susan Rocco-McKeel.)

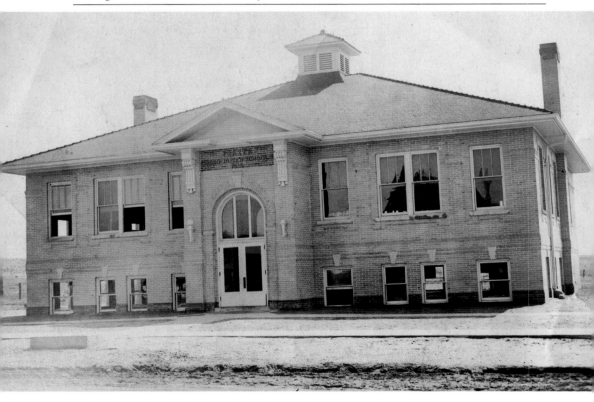

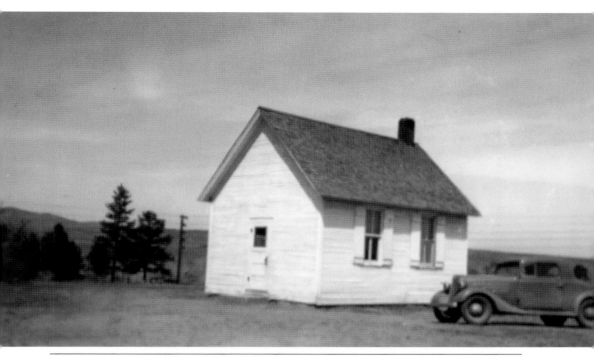

Around the early 1900s, the Spring Valley School served area children. Spring Valley had a post office, blacksmith shop, livery stable, hotel, and cheese factory, none of which remain. Underground springs made the land fertile for crops. Although the school was later used as a residence, the county owns it today. It retains the original chalkboards, hand-dug well, coal house, and outhouse. (Past, courtesy of Douglas County Libraries Archives and Local History; present, photograph by Susan Rocco-McKeel.)

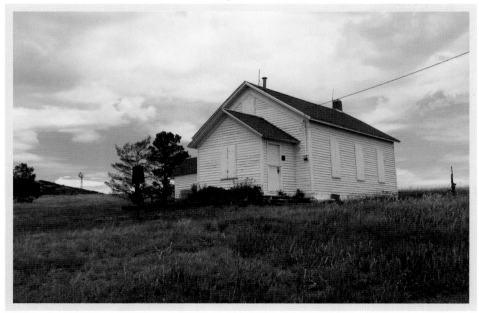

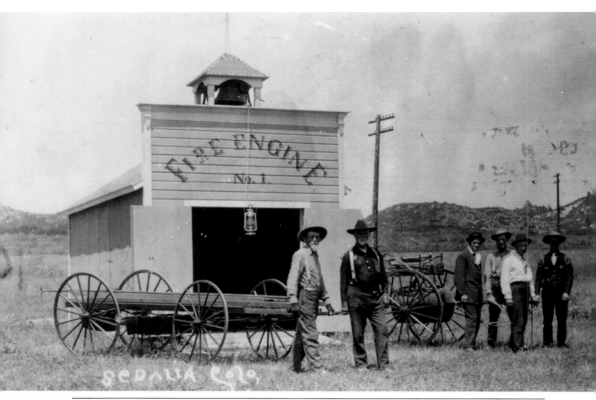

Standing at the Sedalia Fire Station about 1907–1915, are, from left to right, Christian Manhart, Jonathan House, Harry Golke, Henry Manhart, Humpty Schroeder, and Frank Penley. The organization of a volunteer fire department occurred to fight the grass fires sparked near the railroad tracks. With several modern additions, the fire station is still used. Now part of West Douglas County Fire Protection District, it continues as a volunteer department. (Past, courtesy of Douglas County Libraries Archives and Local History; present, photograph by Susan Rocco-McKeel.)

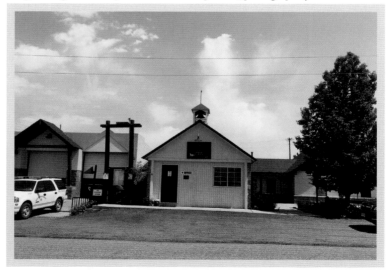

SERVICE AND ASSEMBLIES

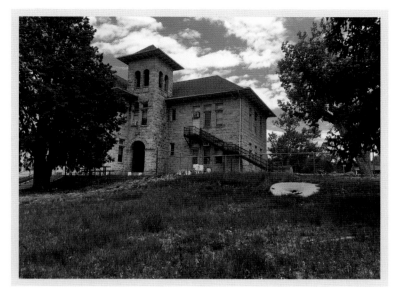

The Renaissance Revival–style rhyolite Cantril school building replaced a wooden structure that burned in 1897. Shown below in 1900, many consider it to be one of the most architecturally significant structures in Castle Rock. Originally an elementary school for grades one through eight, today, Douglas County School District offices and a preschool occupy the building. The building is in the National Register of Historic Places. (Past, courtesy of Douglas County Libraries Archives and Local History; present, photograph by Susan Rocco-McKeel.)

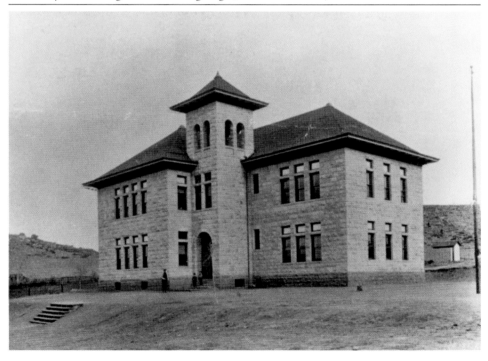

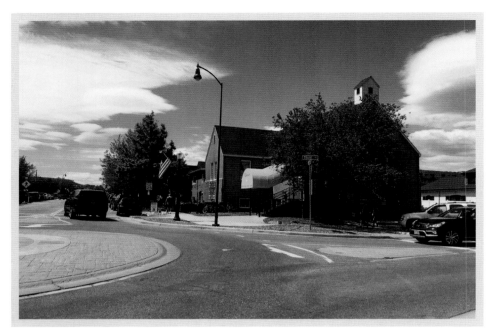

The original building of the Methodist Church of Castle Rock was Castle Rock's first church. Around 1904, the First National Bank of Douglas County made a land trade with the church to swap locations. It moved again in 1922 to make room for the current church building, erected after the other burned. Today, the building is part of a larger commercial complex. (Past, courtesy of Douglas County Libraries Archives and Local History; present, photograph by Susan Rocco-McKeel.)

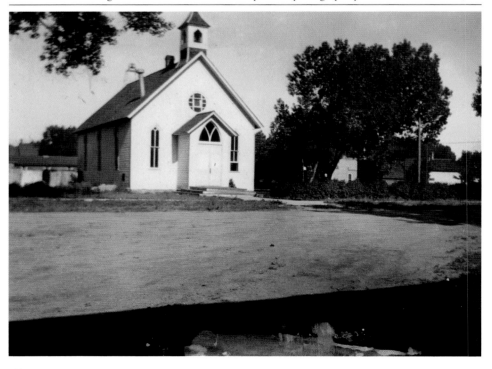

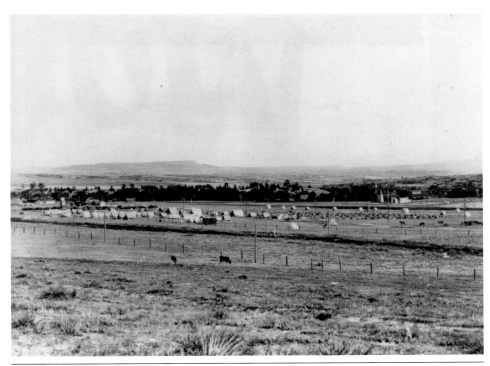

The 1st Colorado Cavalry was formed in 1862 by territorial governor John Evans. This 1891–1911 image shows a military encampment with its tents and horses in Sedalia behind a cow pasture. It may be part of the US Cavalry or the Colorado Cavalry. Ruts of Territorial Road are visible in the camp. It is now a field on privately owned land. (Past, courtesy of Douglas County Libraries Archives and Local History; present, photograph by Susan Rocco-McKeel.)

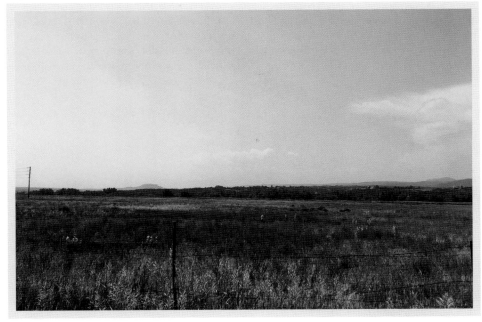

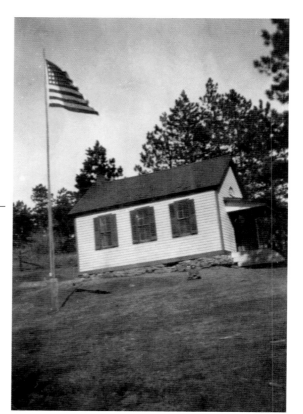

Perched on a mountain, Indian Park School served children of ranches and those who worked the sawmills from 1884 to 1959. The first student body numbered 12 pupils. In the mid-1970s, the Indian Park Schoolhouse Association formed to restore and maintain the school as a community gathering place. The National Park Service listed it in the National Register of Historic Places, and it is also in the state register. (Past, courtesy of Douglas County Libraries Archives and Local History; present, photograph by Susan Rocco-McKeel.)

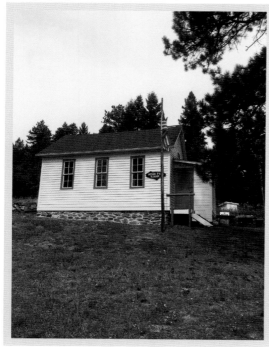

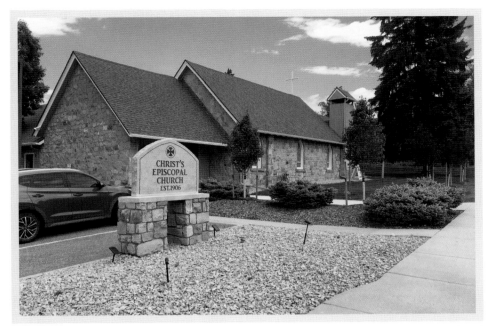

In 1906, Castle Rock residents built Christ's Episcopal Church on a $200 lot. A cornerstone of Colorado marble laid in the building during construction contains a copy of the *Castle Rock Journal* dated August 10, 1906, plus a roster of the then–town officers. Additions have been made and a new worship space added to the site. The original chapel is still used. (Past, courtesy of Douglas County Libraries Archives and Local History; present, photograph by Susan Rocco-McKeel.)

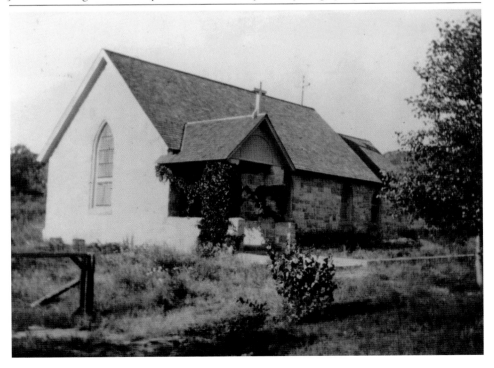

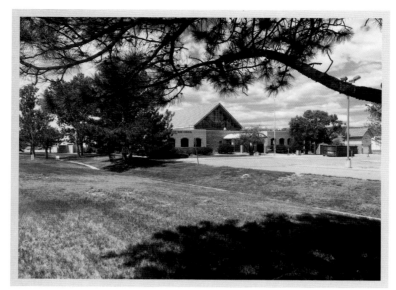

Like other branches, the Castle Rock library had several locations. In 1929, the Douglas County Women's Club opened the county's first library. Douglas County Libraries was established in 1966 and became an independent taxing district in 1990. The Castle Rock branch was at this Plum Creek location in the late 1990s. Today, a school occupies the building. (Past, courtesy of Douglas County Libraries Archives and Local History; present, photograph by Susan Rocco-McKeel.)

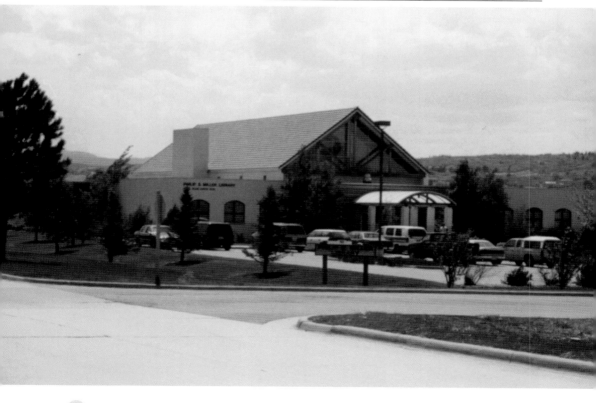

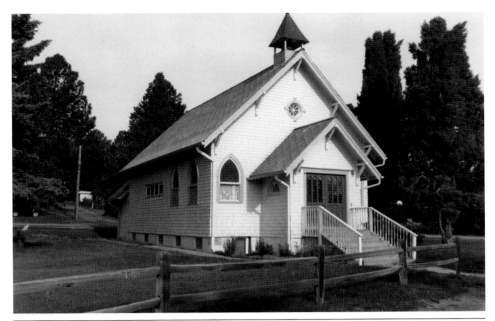

Built in 1927 and shown in 1998, the Louviers Community Presbyterian Church was the only building from the pre-1962 era not constructed by DuPont as part of its company town. DuPont provided the land for the church, but it was built by volunteers, most of whom were DuPont employees. With an addition, the church is now a private residence. (Past, courtesy of Douglas County Libraries Archives and Local History; present, photograph by Susan Rocco-McKeel.)

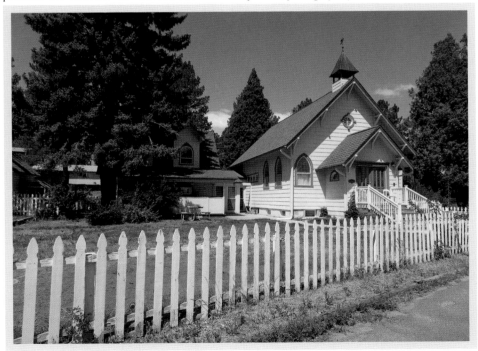

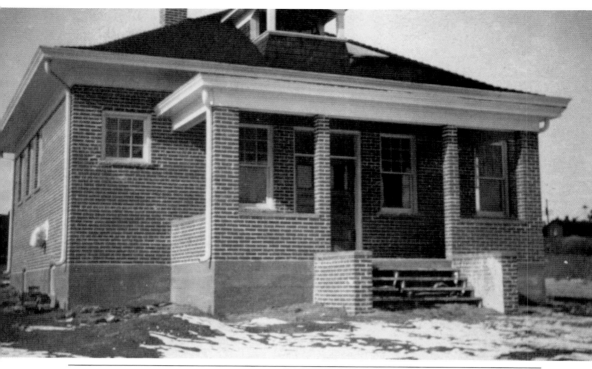

Before Larkspur's wooden school could be moved across railroad tracks and closer to town, a tornado destroyed it. This brick one-room schoolhouse, pictured in the early 1900s, replaced it. Despite additions including a gymnasium and lunchroom, the building was insufficient for the growing student body. Around 1972, a new school was built. The US Postal Service now occupies this building. (Past, courtesy of Douglas County Libraries Archives and Local History; present, photograph by Susan Rocco-McKeel.)

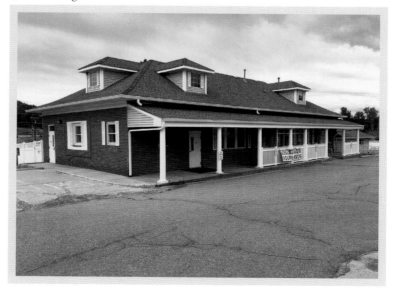

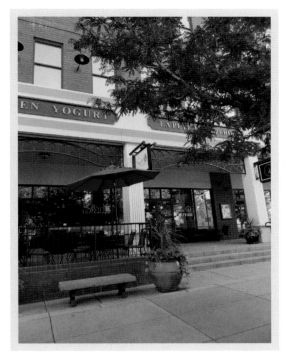

In 1916, Ave Maria Catholic Church was located on Mainstreet in Parker, seen here with unidentified people. Closing in 1955, it was re-established as a new church in 1976 at the east end of Mainstreet. It grew to include an elementary school. After closing, the white chapel became part of St. Matthew's Episcopal's facility, where it is preserved. The original space now contains restaurants. (Past, courtesy of Douglas County Libraries Archives and Local History; present, photograph by Susan Rocco-McKeel.)

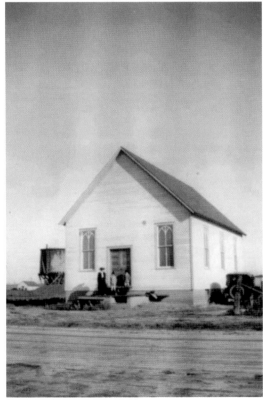

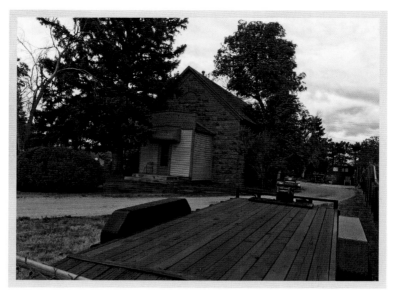

Shown some time between the late 1890s and the early 1900s, the stone schoolhouse in Sedalia was built in 1891. When the one-room schoolhouse needed more space, an east wing was added in 1912. Other improvements included gaslights, a stoker furnace, and water pumped into a drinking fountain. Electricity was added in 1935. A replacement school was constructed in 1951. Currently, it is a private residence. (Past, courtesy of Douglas County Libraries Archives and Local History; present, photograph by Susan Rocco-McKeel.)

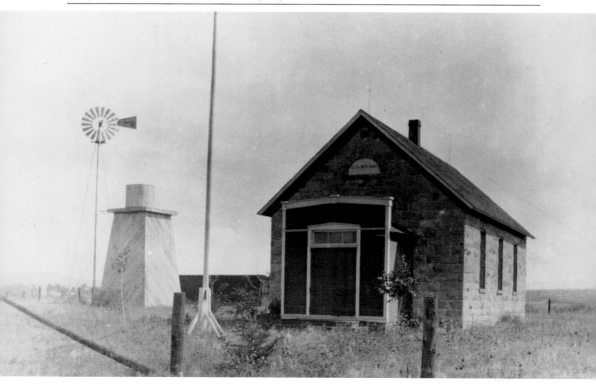

SERVICE AND ASSEMBLIES

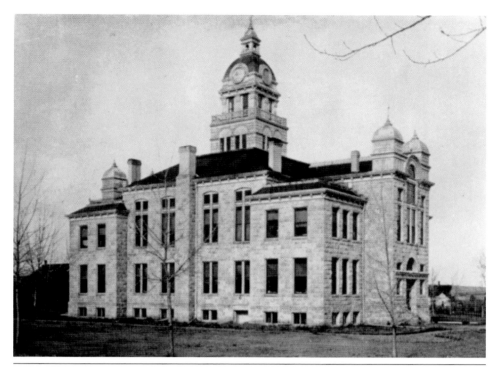

After Elbert County was separated from Douglas County in 1874, the county seat was moved from Frankstown (now Franktown) to Castle Rock. Seen about 1900, this rhyolite building was Castle Rock's second county courthouse. The building was destroyed by arson in 1978. The courthouse was rebuilt with cinder blocks and stone with a facade added later. It is still situated on Wilcox Street. (Past, courtesy of Douglas County Libraries Archives and Local History; present, photograph by Susan Rocco-McKeel.)

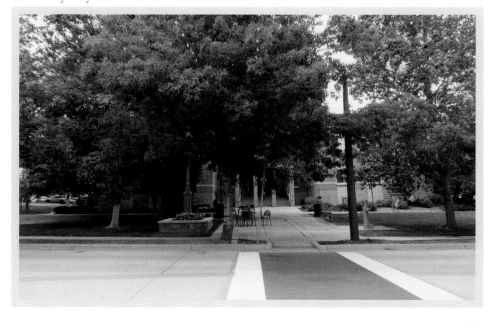

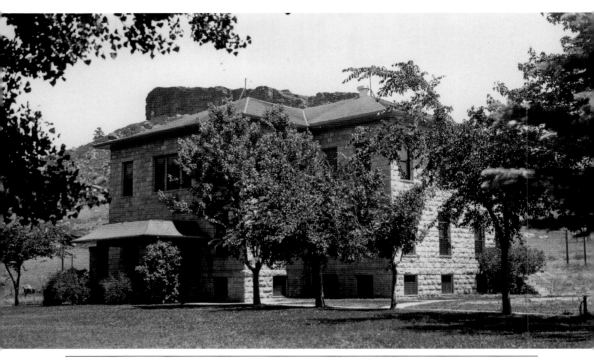

In 1925, Castle Rock Highschool was a rhyolite structure replacing the original brick structure that burned down. Longtime county superintendent of schools Frank Ball pushed for the passage of a new law to establish high schools in Colorado. The law was passed in 1900. The students were moved to a new building in 1967. This is now used for district school administration offices. (Past, courtesy of Douglas County Libraries Archives and Local History; present, photograph by Susan Rocco-McKeel.)

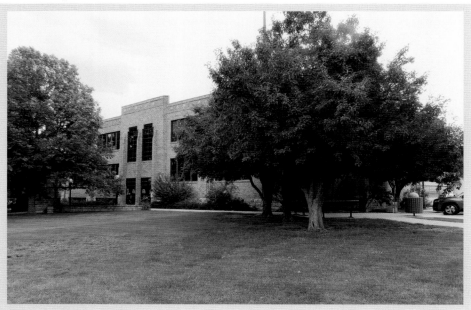

Construction began in 1919 on the two-story, foursquare-style American Federation of Human Rights building and finished in 1924. Its ongoing purpose is to serve as the administration building for the Freemasons. The white stucco building with its blue trim is still in use, and it has been added to the National Register of Historic Places. (Past, courtesy of Douglas County Libraries Archives and Local History; present, photograph by Susan Rocco-McKeel.)

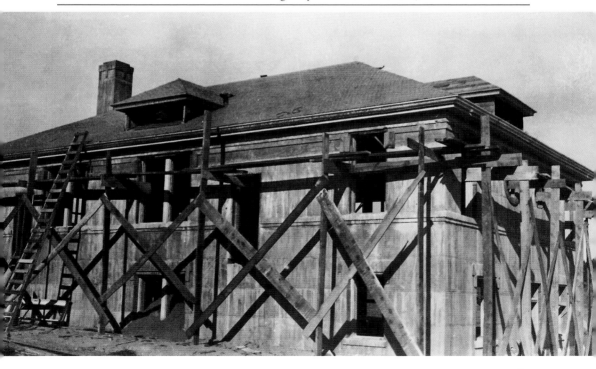

Water recedes after the South Platte River flood in 1965. Fourteen inches of rain fell on Dawson Butte in southern Douglas County during four hours, creating extensive property damage. It remains the most expensive flood in Colorado history. A retaining wall with wooden beams and rock filler sits behind the south side of Castle Rock's courthouse. Above is the south side of the courthouse today. (Past, courtesy of Douglas County Libraries Archives and Local History; present, photograph by Susan Rocco-McKeel.)

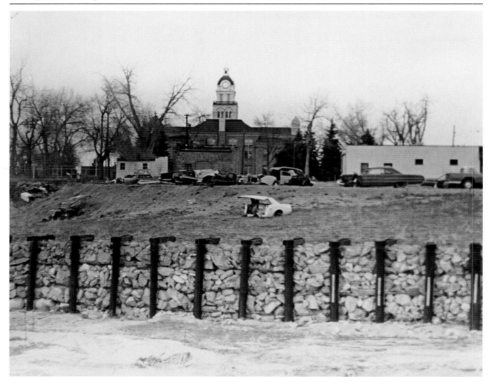

CHAPTER 5

LAND AND LEISURE

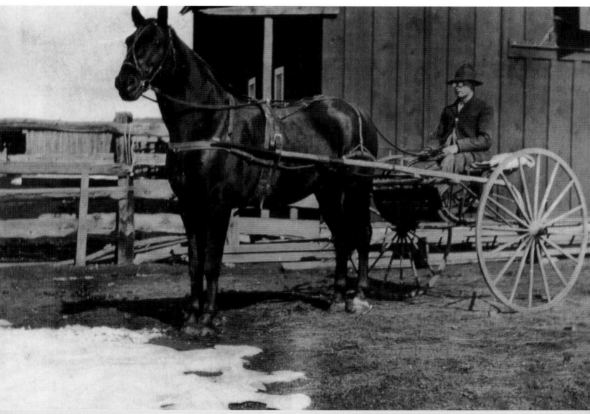

Horses played a working role in Douglas County ranching. Horse racing became a popular activity among county residents. Charles "Fred" Noe is pictured here around 1905 driving a sulky cart with a trotting horse on the Eagle Mountain Ranch, south of Larkspur. The ranch included a harness track for racing in the lightweight, two-wheeled cart. (Courtesy of Bill Noe.)

In 1992, the Parker Cultural Commission was formed. In 2010, the town broke ground on a vacant parcel of land purchased by the Town of Parker for an arts center. Today, the Parker Arts Cultural and Events Center hosts performances, exhibits, and educational programs promoting arts, culture, history, and science that continue to expand. (Past, courtesy of Parker Arts Council; present, photograph by Susan Rocco-McKeel.)

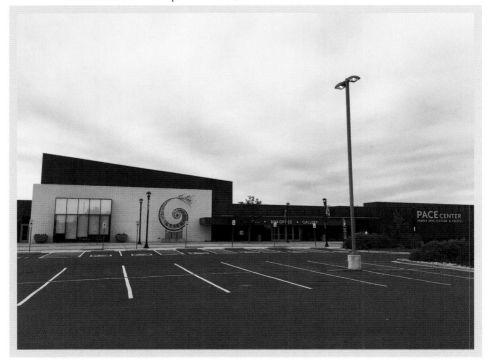

Originally called the Ponce de Leon Chalybeate Springs, the health resort was created by proprietor F.A. Allison using water from a spring reputedly free of harmful sulfates. Around 1890, two eight-room buildings were constructed, later known as the Twin Houses, successful as a health resort for about a decade. One house was demolished and the other moved to a property north of Parker. (Past, courtesy of Douglas County Libraries Archives and Local History; present, photograph by Susan Rocco-McKeel.)

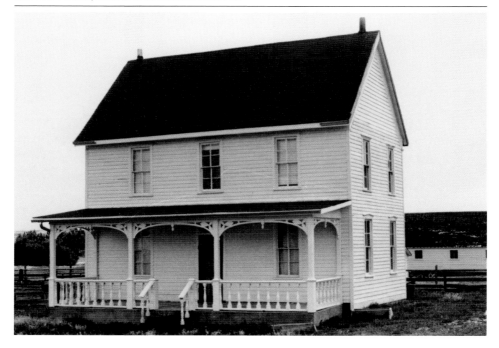

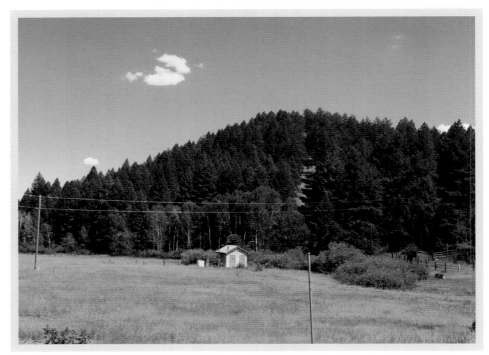

In 1931, the *Record Journal of Douglas County* boasted, "Denver and Steamboat Springs are not the only places in the world to stage Ski Tournaments." This event occurred near Woodbine Lodge, west of Sedalia. In the 1920s, Woodbine Lodge gained attention as a notorious gambling den and brothel hosting Chicago gangsters. Now, Woodbine is an ecology center. The former ski slope is still visible. (Past, courtesy of Douglas County Libraries Archives and Local History; present, photograph by Susan Rocco-McKeel.)

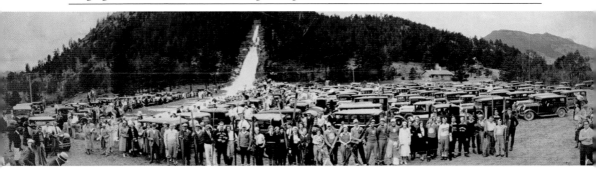

The land shown as it was in 1971 became the Perry Park Golf Course and County Club. Perry Park, a metropolitan district, nestles against the Pikes Peak National Forest. Dramatic red jagged rocks feature in the background behind the golf course's lake. The area was an early stagecoach stop between Denver and Colorado Springs. (Past, courtesy of Douglas County Libraries Archives and Local History; present, photograph by Susan Rocco-McKeel.)

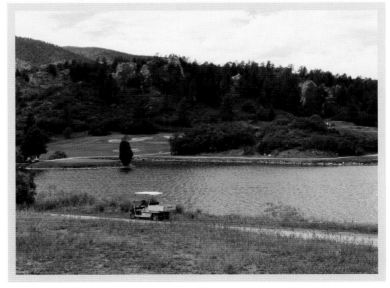

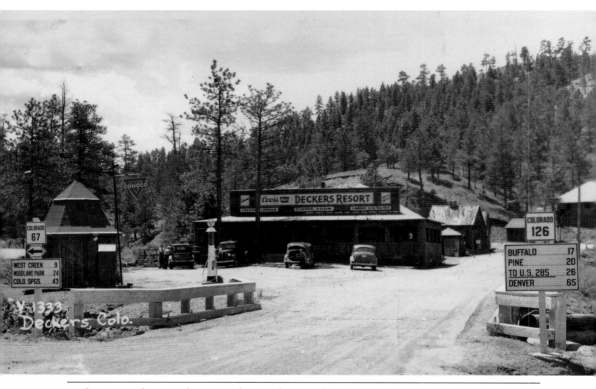

Deckers Resort began in the 1890s when Stephen Decker built a general store near a natural spring in the mountains. He added a cocktail lounge, a dining room, and a gas pump. The resort and its structures are gone. Newer structures feature a café and a general supply store. Deckers has few residents, but it is a destination for fly fishing and hiking. (Past, courtesy of Douglas County Libraries Archives and Local History; present, photograph by Susan Rocco-McKeel.)

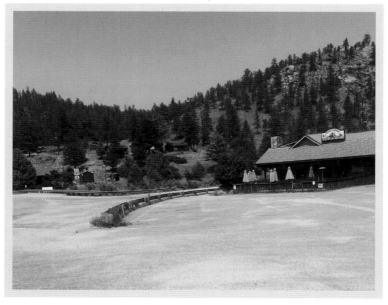

LAND AND LEISURE

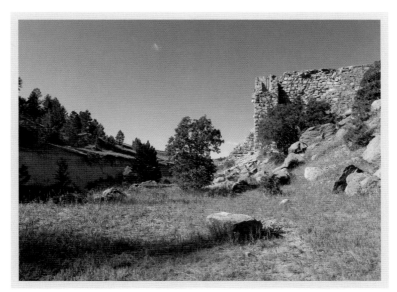

Shown in the early 1900s, Castlewood Canyon Dam was constructed in 1890 for irrigation. Attracted by the rock formations and lush vegetation, picnickers frequented the area. In 1933, a series of thunderstorms filled the reservoir, which broke, sending a 15-foot wall of water surging toward Denver. Protected as a historic site within a state park, the dam ruins are accessible to hikers. (Past, courtesy of Douglas County Libraries Archives and Local History; present, photograph by Susan Rocco-McKeel.)

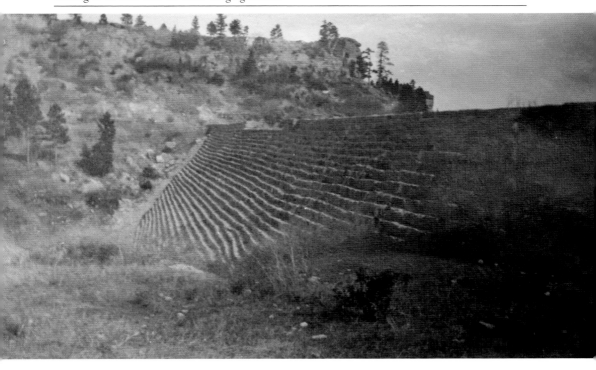

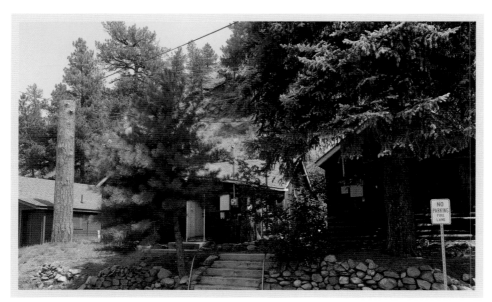

Shown in the 1920s, these rustic wooden cottages accommodated visitors to Deckers Mineral Springs and Resort. Named Daffodil in the 1890s, the community was located along the Platte River. Only one of the original cabins remains, seen in the center of the trees within a cluster of later structures. (Past, courtesy of Douglas County Libraries Archives and Local History; present, photograph courtesy of Susan Rocco-McKeel.)

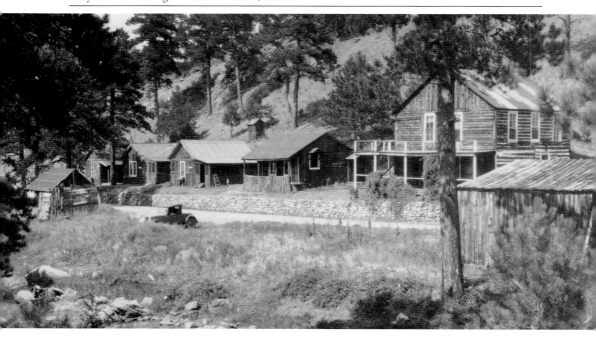

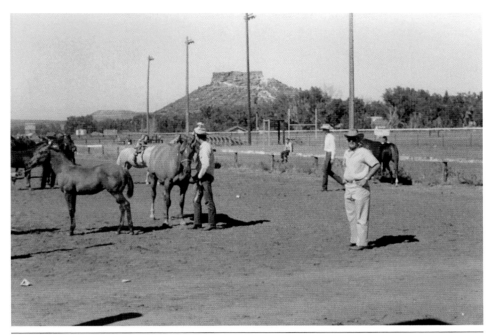

Unidentified people participate in a horse show in Castle Rock between 1950 and 1963. George Triplett organized the first show, which became the precursor to the annual county fair, first held in 1892. This busy venue now features a 29,000-square-foot events center, an indoor and an outdoor arena, and other buildings. (Past, courtesy of Douglas County Libraries Archives and Local History; present, photograph by Susan Rocco-McKeel.)

Rosie (Rueter) Hess and her husband, Percy Hess, ran a cattle ranch on this land west of Parker. Rosie sold the land to the Parker Water and Sanitation District, which built a dam and reservoir with a capacity of 75,000 acre-feet. The Hess homestead was at the base of the dam. Limited recreation is permitted. Archaeological artifacts were discovered providing evidence of human inhabitation dating back 9,000 years. (Past, courtesy of Evelyn Small; present, photograph by Susan Rocco-McKeel.)

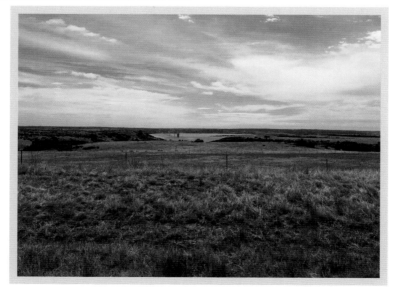

LAND AND LEISURE

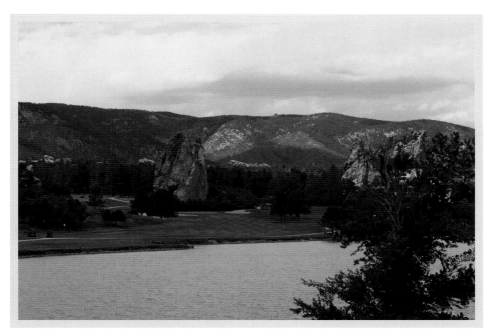

Pleasant Park is shown in an iconic c. 1870 shot by famed Western photographer William Henry Jackson. A horse stands amid wild vegetation, while its unidentified rider kneels. Sentinel Rock is in the background. Today, the area is known as Perry Park and includes a country club with a man-made pond. (Past, courtesy of Douglas County Planning Historic Preservation; present, photograph by Susan Rocco-McKeel.)

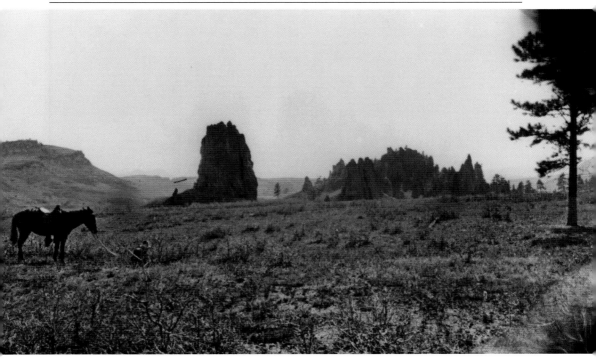

DISCOVER THOUSANDS OF LOCAL HISTORY BOOKS FEATURING MILLIONS OF VINTAGE IMAGES

Arcadia Publishing, the leading local history publisher in the United States, is committed to making history accessible and meaningful through publishing books that celebrate and preserve the heritage of America's people and places.

Find more books like this at
www.arcadiapublishing.com

Search for your hometown history, your old stomping grounds, and even your favorite sports team.

Consistent with our mission to preserve history on a local level, this book was printed in South Carolina on American-made paper and manufactured entirely in the United States. Products carrying the accredited Forest Stewardship Council (FSC) label are printed on 100 percent FSC-certified paper.

MADE IN THE USA